THE WORK OF ATGET

BY

JOHN SZARKOWSKI
AND
MARIA MORRIS HAMBOURG

———— ◆ ————

Springs Industries Series on the Art of Photography

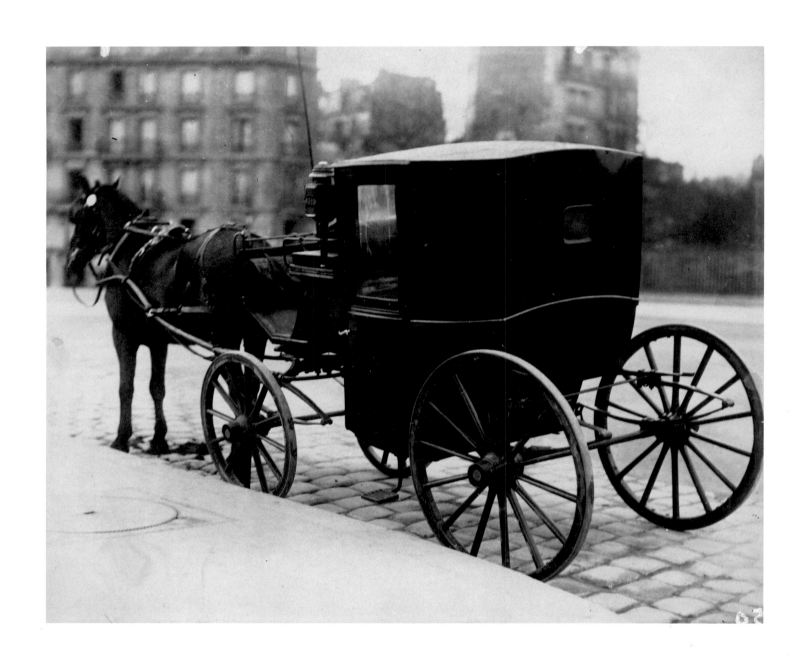

Le fiacre, avant les pneus. (1898)

THE WORK OF
ATGET

VOLUME IV
MODERN TIMES

THE MUSEUM OF MODERN ART NEW YORK

Distributed by New York Graphic Society Books
Little, Brown and Company, Boston

mR

The Museum of Modern Art
11 West 53 Street
New York, N.Y. 10019

Printed in the United States of America

Photo Credits

P. 12. "Une Photographie: La Chambre du Crime." *Le Crapouillot*, Jan. 1929.
Courtesy Sterling Memorial Library, Yale University

P. 21. Edward Weston. *Rocks and Pebbles, Point Lobos*. 1948.
Copyright © 1981 Arizona Board of Regents, Center for Creative Photography

P. 167. Paul Strand. *The Stone Mill, New England*. 1946. Copyright © 1950,
1980 The Paul Strand Foundation, as published:
Paul Strand, *Time in New England*, Aperture, Millerton, 1980

4-1-92 Mercat

Contents

Acknowledgments

ALL of those whose assistance was acknowledged in the first three volumes of this book have contributed to this one also, for the four volumes constitute one book about one artist. The names of those who have been acknowledged earlier are not repeated here, except for those who have been especially helpful in the preparation of this volume.

In considering the relationship of Atget's work to the older vernacular traditions in French art, several recent works have been of great help. Among the most valuable of these was Beatrice Farwell's exhibition catalog *The Cult of Images* (University of California, Santa Barbara, 1977). Two catalogs of the Musée Carnavalet, *Dessins parisiens des XIXe et XXe siècles* (1976) and *Paris vu par les peintres: De Corot à Foujita*, were also very helpful. Works dealing specifically with Atget are acknowledged in the text and notes.

For assistance with special research problems Maria Morris Hambourg and I thank Yvonne Brunhammer of the Musée des Arts Décoratifs, Paris; Professor Samuel Devons of Columbia University; Margaret Nesbit of Barnard College; Jean-Claude Lemagny of the Bibliothèque Nationale, Paris; Tod Papageorge of Yale University; Françoise Reynaud of the Musée Carnavalet, Paris; and Marie de Thezy of the Bibliothèque Historique de la Ville de Paris.

Mrs. Hambourg and I wish to state again our debt to Yolanda Terbell and Barbara Michaels, formerly of the staff of the Museum's Department of Photography, for their essential contributions to our understanding of Atget's work.

As principal assistant on the preparation of this volume and the exhibition it accompanies, Catherine Evans has managed with efficiency and intelligence a broad range of complex editorial and logistical problems. Francis Kloeppel, editor of the series, has earned the deep and lasting gratitude of its authors. Tim McDonough of the Publications Department and Richard Benson, special consultant and supervisor for *The Work of Atget*, are responsible for the quality of production of these volumes. The layout of the present volume follows the overall design established by Christopher Holme in the earlier volumes of the series.

The Work of Atget has been generously supported by Springs Industries, Inc. The belief of Peter G. Scotese and Walter Y. Elisha, successive Chief Executives of Springs, in the value of this project has allowed the Museum to realize what seems to me its most important contribution to date to the record and the interpretation of the art of photography.

JOHN SZARKOWSKI

Understandings of Atget

By the time of Atget's death in 1927 the Paris art world had begun to exhibit some curiosity about the artistic potentials of photography. It was a restrained curiosity, peripheral to the main concerns of that world, and it would be a mistake to overemphasize its breadth or depth; nevertheless a new opportunity for ambitious photographers did exist. When Berenice Abbott's work was exhibited at the Sacre du Printemps gallery in June 1926, the announcement bore a poetic blurb by Cocteau,[1] and the English-language *Paris Times* noted, "Fine photography seems to be pretty well established these days as at least a minor art."[2]

In November of 1927, three months after Atget's death, *L'Art vivant* found it vexing that "our best photographers—the Man Rays, the Abbes, the Berenice Abbotts—do not think of organizing occasional exhibitions of their work. These shows would be for us more interesting than more tedious exhibitions of painting . . ."[3] Perhaps in response to this need (or in self-fulfillment of this prophecy), the Premier Salon Indépendant de la Photographie opened the next May in the Salon de l'Escalier of the Comédie des Champs-Elysées.

The exhibition showed over one hundred prints by eight well-known contemporary photographers,[4] by the Nadars (father and son), and by Adget (*sic*). This exhibition was the first in which Atget was included.

Within a month of the opening, at least six Paris papers and magazines had published reviews, giving appraisals that ranged from sympathetic to enthusiastic. Two of these did not refer to Atget's work, and the remaining four misspelled his name in the same fashion as the exhibition catalog. The critic of the *Revue hebdomadaire* expressed his regret that he had not seen the work of Atget (or of Paul Outerbridge), but he had not been able to find it, even though he had climbed clear to the roof.[5] Waldemar George, writing in *Presse et Patrie*, said that the prints of this "modest magician" evoked the young Monet, Max Ernst, de Chirico, and Louis Aragon.[6] The *Chicago Tribune* (Paris) said that although Atget was a comparative pioneer of the art, many of his compositions ranked with the best of the modern works.[7] The most extensive of the evaluations of Atget's work in the First Independent Salon was by Florent Fels in *L'Art vivant*. Fels saw Atget as a strange romantic poet whose sensibility derived from a past time: ". . . he belonged to that society which has since disappeared, which knew the Boulevard du Crime, the Quinze-Vingts, the Révolution à Paris, the 'bains à quatre sous,' the Funambules, and the Tortoni. [Through his work] gleams the smile of the divine Gérard de Nerval, who also loved the mysterious beauties of Paris."[8] Gérard de Nerval, a precursor of the Symbolist movement in poetry, suffered from spells of insanity and, according to Edmund Wilson, "believed even in his lucid periods . . . that the world which we see about us is involved in some more intimate fashion than is ordinarily supposed with the things that go on in our minds."[9]

A few days after the close of the exhibition Berenice Abbott announced that she had purchased Atget's collection, and by October, when his work was in-

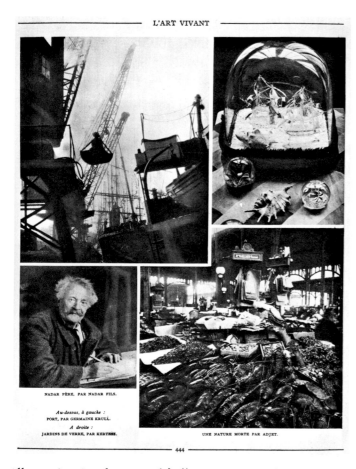

NADAR PÈRE, PAR NADAR FILS.

Au-dessus, à gauche :
PORT, PAR GERMAINE KRULL.
A droite :
JARDINS DE VERRE, PAR KERTÉSZ.

UNE NATURE MORTE PAR ADJET.

444

Illustration in Florent Fels's "Le Premier Salon Indépendant de la Photographie," *L'Art vivant*, June 1, 1928. Clockwise from top left: Germaine Krull, *Port*; André Kertész, *Gardens of Glass*; Eugène Atget, *Still Life*; Nadar (fils), *Nadar (père)*

cluded with a somewhat different group of modernist photographers[10] at the Galerie L'Epoque in Brussels, most critics who wrote on the show had learned how to spell his name. (Adget, Atger, and Atgat continue to appear from time to time.)

During these months articles on Atget increased in number, in length, and in enthusiasm. The Surrealist poet Robert Desnos said that "his mind was of the same race as that of Rousseau," and that he had created a dream capital from the ashes of the dead city.[11] The Associated Press reported that critical opinion saw Atget as the forerunner of most that is good and nearly all that is new in modern photographic art.[12] In *Paris-Midi*, Roger Vailland asked, "Could he be one of those

whom Edgar Poe spoke of, who, while remaining unknown, play an essential role in their epoch?"[13] *Variétés* (Brussels) said that he was "one of the first to feel within himself the soul of the fabulous epoch through which we are passing."[14] Perhaps the apogee of hyperbole was reached in a story, printed in New York by the *Times*, the *Tribune*, and the *Post*, that identified Atget as the "first photographer to formulate the theory that the camera was an artistic instrument rather than a mere machine."[15]

The transformation, within a year of his death, of an unknown commercial photographer into a hero of the modern spirit is remarkable, and the process by which this elevation was effected deserves some consideration.

The brief statement of intention that prefaced the catalog of the First Independent Salon said that the aim of this series of exhibitions would be to show that photography is not a merely mechanical process, "but an art governed by its own laws, that are subordinate neither to reality nor to pictorial art."[16] A few months later Waldemar George, writing in *La Presse* on the conservative Twenty-third International Salon of Photography, clarified further what it was that the supporters of the new salon did not want: "The exhibitors do not recognize the organic laws of the art invented by Daguerre. . . . Too many 'genre' pictures, too many landscapes of lyric inspiration, too many aesthetic nudes bathed in chiaroscuro in the style of Carrière. One would look in vain in the official Salon of the Rue Clichy for photographs by Man Ray, Kertész, Berenice Abbott. . . . These nonconformists and revolutionaries keep away from their conventional colleagues. Photography also has its left, its center, and its right."[17]

Support for the new photography came not from the comfortably ingrown, quasi-official photography societies, nor from the museum or library systems, nor from private galleries, but from the advanced ranks of journalism, especially from the editors of those magazines that had come to depend increasingly on photography. Of the five-man organizing committee of the First Independent Salon, Lucien Vogel was the

editor of *Vu*, Florent Fels was the editor of *L'Art vivant*, and G. Charensol was an associate of Fels.[18] They knew, used, and admired the work of the adventurous young photographers because it was visually exciting and because it seemed alert to and expressive of the spirit of the time.

The young modernists and their friends from the magazines were sure that they, not the exquisite print-makers from the Société Française de Photographie, represented the vital potentials of the medium. They believed that photography had been born honest but had been corrupted by a servile regard for the goals and values of the traditional pictorial arts, and that now, in the bracing new climate of postwar experiment, this error would be rectified. M. F. Agha said later that the war had made people sick of a lot of things, including fake mezzotints.[19]

Agha also said that while the fake-mezzotint period was at its height, "A poor Frenchman named Atget . . . was taking sharp, honest pictures, probably because he did not know better. After his death the Moderns discovered him, made him into a Saint and Martyr of Modern Photography, published several books about him. Honesty is the best policy, even in photography."[20]

It is true that even small revolutions are benefited by honored forerunners, who, being no longer in a position to protest, make the best shibboleths. The First Independent Salon had two forerunners, Nadar, who was famous, and Atget, who was unknown. Nadar's value in this role was compromised by the necessity of dividing his part of the space with his son Paul Nadar, a much less interesting photographer who was still living. In any case Nadar's work was reasonably familiar at least in principle, and it was Atget who was soon being cited in the reviews as the precursor of modern photography.

The story, however, did not proceed as one might have expected, for the interest in Atget continued to grow: the messenger who had been supposed to announce the good tidings came to seem more and more the central actor.

<center>* * *</center>

The unanimously sympathetic reception that Atget's work seems to have received in the press is remarkable. It is true that Atget, as a newly discovered historic figure, offered the journalist a number of attractive features: he had been poor, or poor enough; he had been an eccentric with an *idée fixe;* he had worked long and hard without gaining fame or wealth; he had had a colorful and undocumented youth; and he had died leaving no close family to contradict one's favorite theories. But granting that Atget offered good material for a mythic figure, his pictures themselves seem to have elicited a genuine sense of wonder and surprise. The question that arises in the early reviews is not whether or not the pictures are marvelous—whether or not they could be called art—but rather, how this could be so.

The answers that were explicit or implicit in the responses of Atget's early commentators ranged along an axis that connected two polar positions. One position, favored by Atget's literary benefactors, saw him as a naïve survivor of photography's early days of simple honesty, who had by luck and good intuitions found a subject of modern relevance. The alternate view said that he was an original artist who had somehow learned or discovered capacities of the medium that had not been previously explored, and who had exploited these capacities with intelligence and grace. This second view was favored by young photographers.

The first position was perhaps stated in its purest form by Paul Rosenfeld, who entitled his review of the 1930 Weyhe Gallery show "Paris, the Artist."[21] Rosenfeld said that Atget's pictures "were not at all incommensurable with the work of Hill, Mrs. Cameron and the other fine *naïfs* and primitives of the art; as such, nothing if not the productions of exquisite and characteristic subjects. For Atget, certainly, the matter alone was generative, the camera a pure instru-

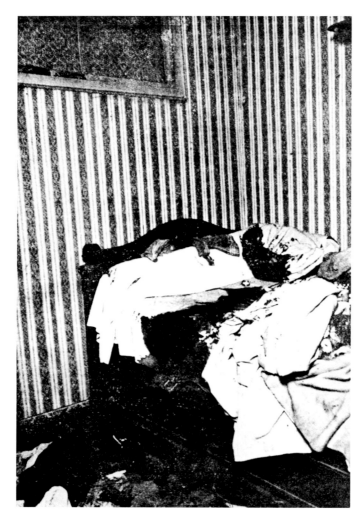

"Une Photographie: La Chambre du Crime," illustration in Pierre Mac Orlan's "Photographie: Eléments de fantastique social," *Le Crapouillot*, January 1929

ment of record." Elsewhere in his review Rosenfeld praised Atget for his discrimination and for the "evergreen delicacy and keenness" with which he fixed his subjects, but he believed nevertheless that "as a medium, photography never appears to have had a peculiar pregnancy or animation for him." Rosenfeld was a close friend and passionate champion of Alfred Stieglitz, for whom "the peculiar pregnancy or animation of photography" was located elsewhere in the body of the medium than it was for Atget.[22]

Although very different in tone, Rosenfeld's view of Atget did not differ greatly in principle from that of Pierre Mac Orlan, novelist and critic, who had written extensively on photography, though never previously

on Atget, when he wrote the introduction to the Jonquières Atget monograph of 1930. Mac Orlan admired the work of Man Ray, Kertész, Germaine Krull, and the portraits of Abbott, but seemed fondest of the anonymous pictures of the news agencies, especially those relating to murder and atrocity, which seemed to him appropriate symbols of the spirit of the age. While Rosenfeld saw Paris as an open-air museum of aesthetic pleasures, Mac Orlan saw it, and the world, as a surreal fantasy rich in physical and psychic violence that was horrifying but fascinating, perhaps in a way even delicious.

Mac Orlan saw photography as a special blessing for the writer. The painter and the draftsman were useless to the writer, for their disciplines, like his, created self-sufficient constructs, formed by a controlling critical intelligence.[23] Photography on the other hand provided in plastic terms "the absolutely free evocation of subconscious thought."[24] Photography produced something much like life itself, but clearer because fixed for contemplation. "It is necessary to see humanity in the magazines of photo-reportage, that is to say, to confront the head of a Chinese severed by the saber of a fat, satisfied executioner, to confront the picture of a young woman in a short skirt and silk stockings sitting on the electric chair, to confront the Russian, Rumanian, Bulgarian corpses, etc., etc., the corpses beheaded and tortured in accord with the laws of 1928."[25] A few months later Mac Orlan wrote an essay on and around a news photograph of a bed in which a murder had been committed: "The actors of the drama are no longer there. There remains nothing but the blood and all the suggestions that it brings to mind, from the physical and moral disgust to the detailed reconstruction of the frightful actions that ended in this simple image, nearly indescribable, but heavy with terror, with a fat, hot smell, and with anxiety when one gives oneself to the pain of meditating on it."[26]

Mac Orlan captioned the picture "Une Photographie: La Chambre du Crime," expressing the special identification in the surrealist sensibility of photography with physical or psychological violation. Mac

Orlan had earlier described photography's ability to arrest movement as the power to cause death for a single second.[27] "F.L.," the critic for *Variétés* (Brussels), claimed that Atget had "unconsciously illustrated the modern detective story."[28] Robert Desnos said that he would like to see an edition of *Fantômas* illustrated by Atget's photographs.[29] In 1931 the literary critic Walter Benjamin summed up the matter: "Not for nothing were pictures of Atget compared with those of the scene of a crime. But is not every spot of our cities the scene of a crime? Every passerby a perpetrator?"[30]

Mac Orlan's conception of the nature and potential value of photography was formed before he had confronted Atget's work, and he did not find it necessary to revise that conception in order to explain the new data. His introduction to the Jonquières book is essentially a restatement of his earlier view of the generic character of the medium, with Atget's name dropped occasionally and gratuitously into the text. At the end of his essay Mac Orlan abandons theory and adds a brief and touching appreciation of Atget as an artist and an exemplar.[31]

During the thirties Walter Benjamin wrote two essays on photography that were little noticed then but have in recent years exerted a powerful influence on art criticism. In the first of these essays, mentioned above, he briefly reviews the history of photography from its beginnings to the present (1931), and slightly revises the standard modernist position: photography had begun well, but with the entrance of businessmen into the field, and then retouching, a precipitous decline set in. Those who had ignored the unexplored possibilities of photography in their eagerness to be admitted to the company of the traditional fine arts were guilty not only of failure of imagination, but of pandering to a moribund authority; ". . . the theoreticians of photography sought for almost one hundred years . . . to accredit the photographer before the exact tribunal he had overthrown." In place of its traditional fine-arts ambitions, Benjamin proposes for photography an alternative preemptive goal: it is necessary to move "the investigation out of the realm of esthetic distinctions into that of social functions." Atget's pictures were "the forerunner of Surrealist photography, advance troops of the broader columns Surrealism was able to field. As the pioneer, he disinfected the sticky atmosphere spread by conventional portrait photography in that period of decline."[32]

Agha said that the war had made people sick of fake mezzotints, but it was not only the fake mezzotint that had lost face; the genuine one had also. Ozenfant said: "Art, let us admit it courageously, manifests certain symptoms of fatigue. Fatigue or disharmony with life? . . . The artisan has climbed high, but the artist is becoming an artificer . . . the lowering of the level of art comes from the artist's imbecile pleasure in the eggs he lays."[33] Léger said, "The artisan will regain his rightful position which he should never have lost, because he is the real creator; . . . the vast majority of professional artists is rendered hateful by personal pride and self-consciousness: they suck everything dry."[34] Yeats said, "Talk to me of originality and I will turn on you with rage."[35]

The Victorian conception of the fine arts as an activity of intrinsic moralizing force had died in the war; afterward artists and philosophers attempted to find in earlier and simpler circumstances a point from which to begin again. To "disinfect," to wipe the slate clean, was seen as a high virtue, and the primitive and the artisan, who had retained simplicity, were heroes. In historical terms, Benjamin protested against the idea of art as an autonomous activity, an antisocial misconception that he saw first clearly expressed in poetry by Mallarmé.

In 1936 the longer essay, "The Work of Art in the Age of Mechanical Reproduction," attempts to introduce into the theory of art certain concepts that are "useful for the formulation of revolutionary demands in the politics of art." Benjamin's argument says that the mechanical reproduction of a work of art undermines the concept of authenticity, by removing the work from its original physical, social, and philosophic context and from the privileges and limitations that this specific context implies. This enveloping cultural context Benjamin calls the *aura* of the work, which

he sees as having its basis in the service of ritual. "For the first time in world history, mechanical reproduction emancipates the work of art from its parasitical dependence on ritual. . . . the instant the criterion of authenticity ceases to be applicable to artistic production, the total function of art is reversed. Instead of being based on ritual, it begins to be based on another practice—politics."[36]

Benjamin does not explain why he considers politics to be something different in kind from other varieties of ritual, or why he believes that the current running between art and ritual (to the degree that ritual itself can, for convenience, be distinguished from art) runs always from ritual to art, and never the other way. It would seem that the relationship between them is in some degree reciprocal, and that an important work of art changes the nature of the ritual that it serves. The concept of art that Benjamin expresses in this essay is very close to what artists call illustration: the application of the techniques of art to make visible a solution that has been reached by other means.

In his 1936 essay Benjamin enlarges his view of Atget's contribution. In addition to the negative virtue of helping to cleanse the air of inherited error, "with Atget photographs become standard evidence for historical occurrences, and acquire a hidden political significance. They demand a specific kind of approach; free-floating contemplation is not appropriate to them. . . . For the first time, captions become obligatory."[37]

The idea of *standard evidence*—presumably the kind of data necessary for verifiable experiment—sits uneasily with the rest of Benjamin's formulation. Photography has achieved such data in the laboratory, in reference to certain areas of the physical sciences, but the goal has proved elusive for photography in the streets,[38] even for Atget. Benjamin would seem to admit as much in stating that the political significance of Atget's pictures is hidden—meaning, of course, hidden to some. Benjamin's conclusion is probably correct; if one wishes to fix the meaning of a photograph to an unambiguous social directive, captions

are necessary. His position is, in theoretical terms, similar to that stated in the same year by the editors of the new LIFE magazine: "Pictures are taken haphazardly. Pictures are published haphazardly. Naturally, therefore, they are looked at haphazardly. . . . The mind-guided camera . . . can reveal to us far more explicitly the nature of the dynamic social world in which we live."[39]

It should be said that Atget's early literary commentators labored under three severe handicaps: they had virtually no reliable facts about Atget's life and career; they had seen at best only a small fragment of his work, and that fragment was undated and unrelated to the large and complex pattern of his ambition and its evolution; finally, they were, almost to a man, ignorant of photography. I do not refer to the kind of academic overview of names, dates, processes, and movements that is now available to any feckless undergraduate, but to the visceral knowledge of possibilities and false promises that comes (if at all) from intensive and intimate work with photographs. Such innocence can be fruitful, for it can allow original perceptions that may be hidden from the expert by acquired patterns of expectation, but it does handicap systematic analysis. For the most part, the literary men leaned heavily on poetic imagery and improvised theory.

Nevertheless there are in these early comments, almost hidden in lush thickets of beautiful writing and cosmic thinking, occasional passages of remarkable clarity and utility. An essay of 1930 by Waldemar George includes this passage: "Atget disdained the panoramic view, the large synthesis, the synoptic picture. His preferred method is analysis, a magic analysis that goes beyond the limits of perception, of visual knowledge. This Rousseau of photography has outstripped his time. In the plastic domain he predicted, from twenty years' distance, the advent of the object as a thing in itself, of the object as a new reality, of the object isolated from its function. Before the Surrealist painters, Atget understood the potential and meaning of facts juxtaposed, confronting each other without any logical line to justify their juxtaposition. A quarter of a century before Louis Aragon he wrote the *Paysan*

de Paris, while probing, while clearing away the waste rock, while stripping naked this immanent mystery that has for a name: Banality."[40] George suggests here the radical nature of Atget's framing—the eidetic concentration with which he eliminated what a more conventional sensibility would have considered essential, and included what in categorical terms might seem foreign, in order to present with greater clarity and boldness those patterns of experience that defined his meaning. George's suggestion that photography creates a new subject by juxtaposing in isolation facts not previously thought related describes a principle that had been intuitively understood by certain exceptional photographers and had on occasion been unconsciously illustrated by many others, but which I had not thought was described in words until a generation later. These sentences by George would seem to constitute the first, and for many years the only, attempt to suggest the technical basis (the photographic strategy) on which Atget's content rests.

<p style="text-align:center">* * *</p>

During this century it has become increasingly difficult, and perhaps finally impossible, to trace the source and sequence of the artistic experiences that form a given artist's mind and vocabulary, or to chart the route by which a new idea enters the tradition—the shared sense of possibilities. The net of channels by which such knowledge is transmitted has become so complex, with so many alternate routes and so many sources of adulteration or dilution or mutation, that it is no longer possible to identify the origin of artistic resources. On his way to the museum the student painter passes twenty billboards, all done by artists who have already been there. Tradition is no longer transmitted by a clean exchange from master to student, and it cannot be adequately studied in those terms.

To this rule there are occasional exceptions, and of these the entry of Atget's work into the larger world of photography is one of the most extreme. Until 1928 Atget's work was unknown to photography; it had had no exposure and thus no influence. That part of it that was specific to Atget rather than generic to photography could then be seen in a pure state, uncolored by the subsequent expansions and reductions of his followers and interpreters. By 1931 four of this century's most distinguished photographers had independently recorded their response to the work.

The first photographer of stature to write on Atget was, appropriately, Berenice Abbott. Her first essay on his work appeared in the September 1929 issue of *Creative Art*;[41] her writings since have refined and expanded the view stated there, but have not changed its central meaning. In her view Atget represented not the return to sound first principles, but a new beginning. "In looking at the work of Eugène Atget a new world is opened up in the realm of creative expression. . . . He is the modern forerunner in the sense that hitherto [photography] has been used as a small trade for very limited purposes." The first sentence of her essay says, "It is not profitable to discuss whether or not photography may be an art." The boldness of this beginning recalls Max Planck's observation that it is "annoying as can be, to find after a long time spent in toil and effort, that the problem . . . is totally incapable of any solution at all—either because there exists no indisputable method to unravel it, or because . . . it turns out to be absolutely void of all meaning—in other words, it is a phantom problem, and all that mental work and effort was expended on a mere nothing."[42] It was Abbott's forlorn hope that she might thus move her audience's attention from the phantom problem of categorizing to the real one of understanding Atget's creative achievement, and the new opportunities it proposed. She continues, "Indeed, the expression that this medium affords is so utterly new that some time must elapse before we conquer our surprise."

Abbott's judgment was expressed in deeds as well as words. As a young foreigner of very slender means

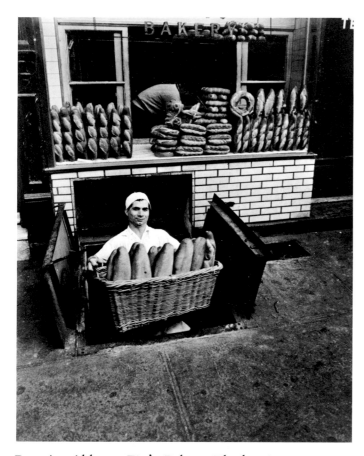

Berenice Abbott. *Zito's Bakery, Bleecker Street*. c. 1940.
MoMA, anonymous gift

Walker Evans. *Untitled*. c. 1928. MoMA, gift of Dr. Iago
Galdston

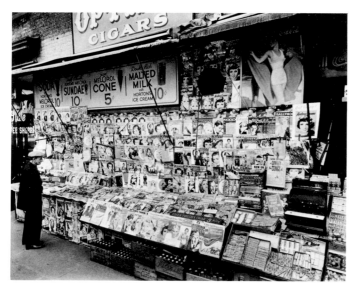

Berenice Abbott. *Newsstand, 32nd Street and 3rd Avenue*.
1935. MoMA, gift of Connecticut Valley Boys School

she took on the burden of buying and preserving At-
get's residual collection, when no institution, French
or foreign, was aware of its importance.[43] From that
moment she served for forty years as Atget's artistic
executor, impresario, curator, archivist, and agent,
while simultaneously pursuing her own career as a
working photographer. It is remarkable that she served
these sometimes contradictory roles without ever los-
ing sight of her original goal—that Atget's work be
preserved and known.

When Abbott first saw Atget's work she was a
studio portrait photographer. After she acquired At-
get's work and returned to America, the character and
ambition of her work changed radically. During the

thirties and forties she devoted the larger part of her energies to documenting the architecture, street life, and commerce of New York, and it is clear that her sense of opportunities had been profoundly influenced by Atget's example.

Late in 1931 both Walker Evans and Ansel Adams published appraisals of Atget's work, Evans in a one-thousand-word omnibus review of five photography books of exceptional importance that had been published within the preceding three years. The general thrust of Evans' piece conforms to the familiar modernist position, as reflected in the review's title: "The Reappearance of Photography."[44] Of Atget he says, "His general note is lyrical understanding of the street, trained observation of it, special feeling for patina, eye for revealing detail, over all of which is thrown a poetry which is not 'the poetry of the street' or 'the poetry of Paris' but the projection of Atget's person." Evans thus rejects out of hand the view that Paul Rosenfeld had expressed earlier in the year. Atget was not to be regarded as the instrument through which a culture had drawn its self-portrait, but as an individual who had made choices in the light of his own understanding. Evans was not prepared to speculate as to the basis of this understanding: ". . . his story is a little difficult to understand. . . . just what vision he carried in him of the monument he was leaving is not clear. It is possible to read into his photographs so many things he may have never formulated to himself. In some of his work he even places himself in a position to be pounced upon by the most orthodox of surrealists."

It was Evans' recollection, forty years later,[45] that when he first saw Atget's work (perhaps in 1929, surely by 1930) it served as a confirmation of a change that had already taken place in his own work. Evans had been a nominal student in Paris for several months in 1927; he recalled being interested only in literature then, and in making occasional casual snapshots in the same spirit as would any other young adventurer momentarily free in the capital of the world. He was not aware of Atget's name or work. On his return home he began seriously to teach himself photography, partly because he had become fascinated with it, and partly

Walker Evans. *Girl in Fulton Street, New York*. 1929. MoMA, purchase

because he found himself paralyzed by writer's block. During 1928 and 1929 he seems to have worked his way through the prevalent Cubist-haunted photographic vocabulary of the twenties, making photographs that were graphically strong, acrobatic in viewpoint, semiabstract, hard-edged in design, and a little soft in content. During the same years, but increasingly in 1929, Evans began to make candid snapshots that were concerned less with pictorial structure than with the psychology of anonymous street life. These pictures possess a new realism and immediacy, and assume larger risks than the exercise in geometric pattern-making that had predominated earlier in this brief apprenticeship period, but they do not prepare us for the sudden emergence, sometime around the turn of the decade, of Evans' cool and classical plain

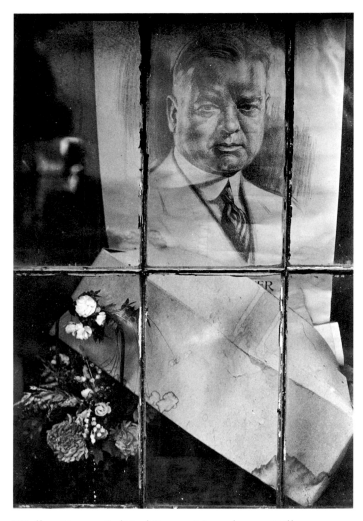

Walker Evans. *Political Poster, Massachusetts Village.* 1930–31? Study Collection, MoMA

those qualities that we might guess Evans found in Atget, and it would seem improbable that they were all made in the few weeks remaining to 1929, after the evening in Abbott's apartment.

Whatever the details, the profound effect of Atget on Evans—at least as a corroborator of his own intuitions—is surely clear. Evans never lost his early interest in the small camera, or in the tangential view of ephemeral life that is its special métier, but that interest takes second place in his work to his vision of a photography that would be still, dense, and permanent, and that would establish the essential image of his time and place. In a lecture two days before his death he said: "I don't like to look at too much of Atget's work because I am too close to that in style myself. . . . It's a little residue of insecurity and fear of such magnificent strength and style."[48]

It is surely unnecessary to add that Evans was not an Atget follower. In style Evans' pictures are flatter, his subject matter more restrictively framed, more sternly isolated from an encompassing space and an enfolding atmosphere, more sharply and more coldly drawn. In spirit his work seems the report of a sympathetic, intelligent, and knowledgeable visitor—like Tocqueville, deferentially pointing out to the native what he should respect and study. The quality of easy, familiar possession that imbues Atget's work was unavailable to Evans, and as a man of principle he declined to pretend otherwise.

Ansel Adams' first response to Atget appeared almost simultaneously with that of Evans; it was consonant with it in substance, and even more generous and grateful in tone. The importance of Atget lay not in the quaintness of his subject matter, but in his "equitable and intimate point of view. . . . The Atget prints are direct and emotionally clean records of a rare and subtle perception, and represent perhaps the earliest expression of true photographic art."[49]

Adams' unreserved enthusiasm is especially remarkable when one considers how deeply foreign Atget's subject matter was to him, how foreign even the gray Paris light. His response may be illuminated by another review that he wrote the following month, on the work of his neighbor Edward Weston. After iden-

style, in which the architecture and still life of everyday experience are seen like the monuments of the ancients, tense with immobility.

James Stern reported, almost a half-century after the fact, that he and Evans had seen Atget's prints at Berenice Abbott's apartment in November of 1929, and adds, "Surely it is not invidious to wonder what kind of Evans we would have, which way his art would have developed, had there never been an Atget?"[46]

A crucial shift does occur in Evans' work at this time; the new intensity of style and the new confidence in the face of vernacular fact do suggest the influence of Atget. The evidence is not altogether clear. *American Photographs* (1938), Evans' first monograph, reproduces three photographs[47] dated 1929 that possess

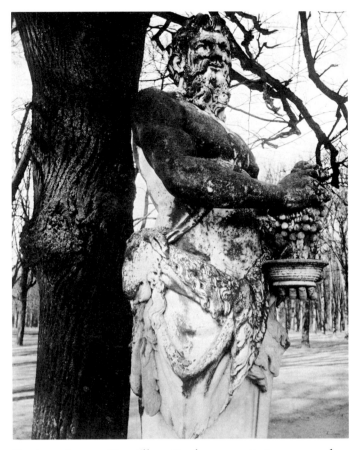

Eugène Atget. *Versailles, Bacchus.* 1921? Atget number unknown

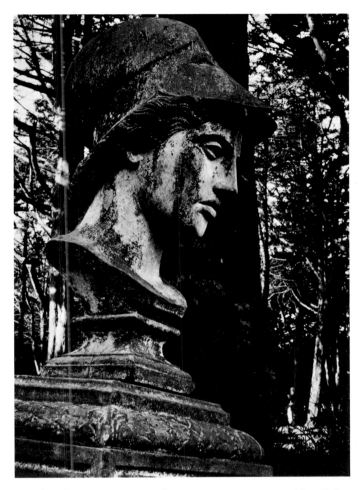

Ansel Adams. *Sutro Gardens.* c. 1934. MoMA, gift of the photographer

tifying Weston as one of "scarcely a dozen" workers in the history of the medium who had realized the artistic potentials of photography, and after praising his taste, vision, and technique, he delicately raised a reservation: "One may occasionally question the highly decorative aspect of some of his work. . . . he often makes his objects *more* than they really are in the severe photographic sense. While succeeding therein in the production of magnificent patterns of definitely emotional quality, he occasionally fails to convey the prime message of photography—absolute realism. . . . I feel that photography will find itself in the not too distant future reverting to the simplicity of style that distinguishes the historic work of Atget."[50]

The basic stuff of Atget's world is so different from that of Adams' that it is difficult to compare their work. But there is in Adams' pictures of the thirties a quality of tact and modesty before the prior claims of his subject matter, a reluctance to reshape the world too roughly to make it serve the needs of grand design, that perhaps expresses in his own art what he loved, when still in his twenties, in Atget.

Late in 1930 Weston himself had been sent the Jonquières Atget book by the painter Jean Charlot. Weston's response is of extraordinary interest, and perhaps of value in identifying the qualities that are central to his work. Carl Zigrosser[51] had earlier told Weston that he considered Atget one of the greatest of all photographers, and it is not difficult to imagine the pleasure with which Weston looked forward to the discovery of a worthy new name to add to his tiny list of serious photographers. He recorded his disappointment in his diary: "I was prepared to be thrilled —or that's a cheap word, let's say deeply moved! In-

Edward Weston. *Cypress, Point Lobos*. 1929. MoMA, gift of David H. McAlpin

Eugène Atget. *Saint-Cloud*. 1924. sc:1234

stead I was interested—held to attention all through the book—but nothing profound.

"Atget establishes at once with his audience a sympathetic bond: for he has a tender approach to all that he does,—a simple, very understanding way of seeing, with kindly humor, with direct honesty, with a reporter's instinct for items of human interest.

"But I feel no great flame: almost, in plate 94 of tree roots—if I had seen it before doing my own I would have thought it great. How much it resembles my viewpoint."[52]

Weston also found Atget's technique unsatisfactory. This verdict was due in part to having seen the work only in the Jonquières book, which Evans had found so badly reproduced as to make him wonder if it might be a pirated edition of an earlier book. But more serious in Weston's mind than the lack of brilliant print quality and impeccable finish was (I think) the quality in Atget's seeing that might be suggested by the words elastic, informal, syncopated, and free, and the characteristic lack in his designs of the variety of unyielding rigor that identifies Weston's best work, and that in his lesser work borders on rigidity, and occasionally mere neatness.

Weston's disappointment was genuine, but his appraisal was hedged around with qualifications: ". . . his intimate interiors,—the bedrooms,—are as fine as Van Gogh: and his store windows a riot,—superb. In these I find him at his best, and in such plates as his merry-go-round and circus or side show front." And whatever its perceived failings, Atget's work did cause Weston to reconsider his own: "What I admire most of all is the man's simple honesty. He has no bag of tricks. He makes me feel ashamed in recalling certain prints—most all destroyed now—in which I found myself trying to call attention with cleverness, or shall I say by a forced viewpoint—for I hope I have never been cheaply clever!"[53]

By 1938 Weston seems to have resolved his ambivalence. In a letter to Nancy Newhall he writes: "Atget was a great documentary photographer but is misclassed as anything else. The emotion derived from his work is largely that of connotations from subject matter."[54] Thus Weston adopts the position that Paul Rosenfeld had stated earlier. By recourse to the label *documentary photographer*, a term not in common currency eight years earlier, he establishes the relationship between himself and Atget: each was a champion at a different game.

It was not in fact as simple as that. In 1930 Weston had indeed tended to believe that the "connotations of subject matter" were not part of the creative photographer's problem, but during the thirties he moved away from that position, and what is new in his work comes to express a growing interest in the referential meanings of his subject matter. The Brancusi-pure

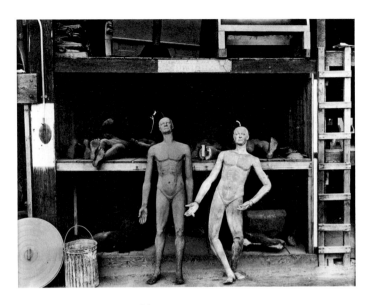

Edward Weston. *Rubber Dummies, M.G.M.* 1938. MoMA, gift of Edward Steichen

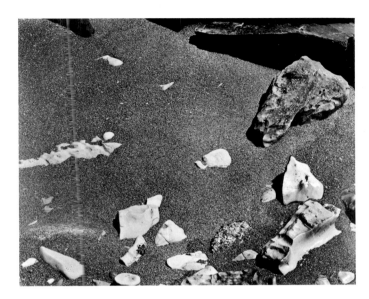

Edward Weston. *Rocks and Pebbles, Point Lobos.* 1948. Edward Weston Archive, Center for Creative Photography

nudes and shells and vegetables and nature fragments with which Weston began that decade are joined by a new body of work that celebrates a broad, humanized landscape, filled with specific temporal references, even with humor. More subtly, Weston's taste for uncompromisingly architectonic picture structure also relaxes noticeably during the thirties. As his viewing distance lengthens he includes more, and more diverse, objects onto his ground glass, his designs become more fluent in their balance, his spaces deeper and more atmospherically described. In meaning and in style, Weston's work from 1930 onward moved toward Atget's example.

It is impossible to identify the source of these changes, or even to be confident that they were brought about by any force other than the natural unfolding and efflorescence of his own native intuition. But it is difficult to believe that Weston's reluctant and troubled disappointment in Atget, and the reconsideration of his own values that the experience prompted, left no mark. Weston did not quite like Atget's work; it spoke in an unfamiliar accent, and disregarded values that were deeply important to him. But the evidence of his pictures suggests that he learned from it.

Most of the best of that remarkable generation of photographers who were born during the Edwardian decade and were in their twenties when Atget's work

Edward Weston. *Eroded Rock, Point Lobos.* 1930. MoMA, gift of the photographer

came to view—including Adams, Alvarez-Bravo, Brandt, Cartier-Bresson, and Evans—were directly touched by the experience of Atget's work, and have acknowledged its deep influence. Bill Brandt "loved the poetry of his street scenes, the beggars, the prostitutes, the musicians, and was enchanted by the steep perspective of his cobblestone streets."[55] Cartier-Bresson's earliest photographs, made with a small plate camera on a tripod, closely echo Atget in sub-

Manuel Alvarez-Bravo. *Optic Parable*. 1931. Study Collection, MoMA, gift of N. Carol Lipis

Henri Cartier-Bresson. *Rouen*. 1929. MoMA, gift of the photographer

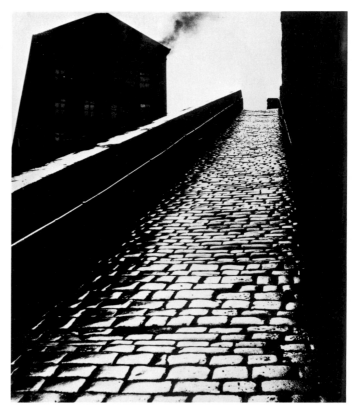

Bill Brandt. *A Snicket in Halifax*. 1937. MoMA, purchase

ject matter and in structure;[56] his more important debt to Atget, however, is not a matter of style or technique, but is expressed in the awareness of life as an adventure revealed in unconsidered details, and in the aspect of the chance encounters of things.

The photographer who first recognized an unsuspected value in Atget's work seems to have been unaffected by it as an artist. Man Ray was fundamentally a studio photographer, concerned with the kinds of synthesis that could be achieved by arrangement, by highly controllable artificial light, by variation of normal darkroom procedures. Whether or not the fact conforms to Surrealist theory, he was a highly calculating artist. If his photographs hoped to touch the reality of dreams and the subconscious, there was—in the making of them—less room for the play of intuition or for collaboration with chance than there was in Atget's method, in which the number of possibilities contained in every motif was infinite, and beyond the reach of calculation. Near the end of his life, speaking of his recollection of Atget, Man Ray said: "I

would drop in once in a while and pick up a few prints. He had thousands of prints. . . . These prints were documents, and most of them were uninteresting, but I finally acquired thirty or forty. . . . They're the ones that have been most reproduced, because they have a little dada or surrealist quality about them."[57]

Man Ray presumably bought his Atgets as food for thought and casual delectation. It is not unusual for painters to collect photographs informally, along with a wide range of miscellaneous visual materials; these are by no means always intended to serve as source material for paintings, but as riddles to contemplate, as reminders, visual jokes, traces of far places and exotic people, as references to things of beauty, and sometimes as things of beauty. Ozenfant's *Foundations of Modern Art* is illustrated largely by photographs that are so uniformly diverting, so divergent in their original functions (photographs of news events, tribal customs, street scenes, scientific apparatus, plant forms, buildings, aerial views, battleships, colleagues, etc.), and so elliptically related to the subjects of the text, that this aggregation is clearly the work of a twentieth-century painter.

Man Ray's early attitude toward Atget would seem to have been one of sympathy and admiration, tinged with bemused condescension. There would have been little in his experience to prepare him for an artist appearing in so unfamiliar a guise. As Florent Fels said, Atget was a man of another time, a child of the Second Empire, only half a generation younger than Renoir, with whom he perhaps shared some perspectives and attitudes. Both men came from families of artisans, and Renoir in his youth supported himself happily as a painter of porcelain and window shades. Like Atget, he read the French classics, and Alfred de Musset and Dumas *père*, and apparently little that came later.[58] According to his son Jean he thought that "Heaven grants its revelations only to the humble. Renoir went so far as to eliminate the word 'artist' from his vocabulary. He thought of himself as a 'workman-painter.' "[59]

In Man Ray's casual recollections of Atget he emphasizes the man's apparent modesty, a quality, perhaps, which he found especially puzzling in an artist.

Henri Cartier-Bresson. *Santa Clara, Mexico*. 1934. MoMA, gift of Willard Van Dyke

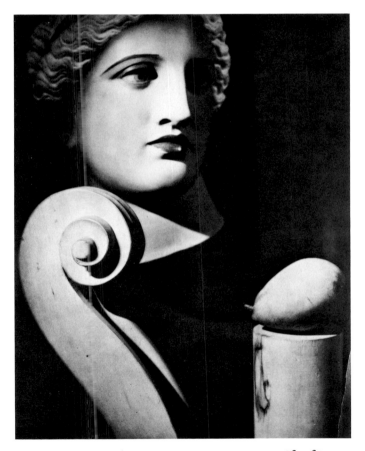

Man Ray. *Classical Composition*. 1931. MoMA, gift of James Thrall Soby

In 1975 he said, "He was a very simple man, he was almost naive. . . . I don't want to make any mystery out of Atget at all."[60] Twenty years earlier, in a letter to Minor White, commenting on what seemed to both men the shortcomings of Atget's technique, he had said, "I think he was an artist, not a perfectionist."[61]

As the years went on he might understandably have become a little impatient with young visitors who came to ask not about his own work, but about his recollections of the strange *naïf* who had once lived down the street.

* * *

The first years of Atget's posthumous fame saw an outpouring of critical response. By 1932 comment had virtually stopped, except for periodic pieces by Abbott that were essentially amplifications of her earlier perceptions. Perhaps the available critical positions had been claimed and occupied, to the degree that this could be done on the strength of intuition; the next step required patient analysis of the oeuvre, with the hope that the work itself might provide the knowledge that would allow reconstruction of its functional and categorical structures, and that this in turn would clarify Atget's intentions, values, and working patterns, and his development, if indeed he had had a development.

If this was the logical next step, it was under the circumstances impossible. In 1929 Abbott had returned to the United States, taking her Atgets with her. The work remaining in Europe was scattered in private collections, largely unknown, or preserved in institutions where it was generally organized according to its subject matter, and not easily retrievable for study. In New York Julien Levy, by then co-owner of the collection, mounted Atget shows in his gallery in 1932 (with Nadar) and 1936, and although they were commercial failures (as his exhibitions of photography uniformly were), they kept Atget's name and work visible. Nevertheless, opportunity for study of the work was very limited. Abbott was a working photographer, not an institution, and in the confines of her apartment the collection was for most purposes virtually in dead storage.

During the twenty years following Abbott's return to the United States, the most ambitious effort at a fresh critical look at Atget's achievement, based on the review of a large body of his work, was that undertaken in the late forties by Ferdinand Reyher. Reyher, a novelist and screenwriter, was interested in photography as a technique that had exerted a powerful influence on the sensibility of its time. He had made a photographer the central figure of his unpublished (and lost) novel "Tin."[62] Although the novel was set in mid-nineteenth-century America, the photographer's ideas and personality were based largely on Reyher's extensive research on Atget, which included study of French collections and interviews with people who had known Atget. In addition to the novel, Reyher planned a monograph on Atget, to be based on the Abbott-Levy holdings. Abbott seems originally to have given Reyher virtually unlimited access to the collection, but after a falling-out she withdrew her cooperation, and the project was aborted. Except for his often undecipherable research notes, now in the archives of The Museum of Modern Art,[63] nothing remains of Reyher's work on Atget but the long captions that he wrote for an exhibition held in 1948 at the Addison Gallery of American Art.

Reyher's captions do not mention Surrealism, or use the word document, or suggest that we should be grateful to Atget because he was the precursor of something else. In twenty-five short essays, some scarcely longer than epigrams, he attempts to suggest the content of the pictures. He said that Atget photographed "this everlasting moving in of life on history, now roughly, now gently, but always irrevocably dispossessing it, sending it begging to institutional asylums . . . or absorbing it, adapting it, for Paris is all centuries." He reflected on the dramatic stillness and poise of Atget's work, and decided that "he was anything

but unaware of motion. He simply caught the longer profounder motion of things." Reyher understood that the pictures were artifacts formed by an intelligent will. Atget was concerned with "form, that basic abstract reality lying within the appearance of things. . . . He did not take Paris, he took photographs . . . he knew the rectangle of his heavy 7.2 x 9.6 glass plate, and where to stand his camera. The basic thing that matters is where a man stands. All the rest is picture making."[64]

The caption form does not lend itself to systematic analysis. Reyher's short essays attempt instead to show us that Atget's work is the expression, first of all, not of an artistic method or an intellectual principle, but of an original sensibility.

Harold Becker's ten-minute 1964 film on Atget[65] expressed a new critical view in spite of the fact that the film is wordless—or perhaps in part because of that fact. In Becker's film the hard edge of specific fact is subsumed into an impressionistic evocation of what Walker Evans might have called "the poetry of Paris," placing the phrase in quotation marks to establish a fastidious distance between it and himself. If the film restricts itself to one chord from the scale of Atget's interests, it is a true chord, and a useful corrective to the tempting but imprecise notion that Atget was a Gallic Evans.

In 1968 John Fraser published the essay "Atget and the City"[66] and brought a new level of scholarship to the discussion of Atget's work. It would seem that Fraser studied more Atget photographs—in the original or in reproduction—than had any earlier commentator except Abbott (and possibly Reyher). His general position is that the work is less about French culture, as that term would normally be understood, than about civilized life, and that it is in Atget's grasp of the intimate interplay between the undomesticated rights of nature, even human nature, and the arts of social structure that his particular genius lies. Fraser also observes that Atget's pictures—although the age of the objects described within them often spans cen-

turies—do not make invidious comparisons between new and old. "It seems to me that Atget's astonishing poise, his continual voracious interest, curiosity, wholly unsentimental love and respect for so many different forms of existence, his Rembrandtesque ability to treat in exactly the same spirit the conventionally beautiful and the conventionally sordid, issued from the fact that in *his* approach to the energies of the city he was able wholly to avoid [opposing the past to the present]."[67]

By the time of Reyher and the Atget critics of the fifties and sixties—Fraser, Arthur Trottenberg, Leslie Katz, Romeo Martinez, Jean Leroy, Ivan Christ, Clement Greenberg, and others—Atget was accepted as a historic figure; if the work remained a mystery it was no longer a surprise, and it was widely accepted that its maker was, according to one or another definition of the term, an artist. In the twenty years that separated the exhibition at the Salon de l'Escalier from the one at the Addison Gallery, the public for serious photography had grown larger and more catholic in its perspectives, especially in the United States. During these decades earlier work by other working photographers—Jacob Riis, Lewis Hine, Timothy O'Sullivan—that would formerly have been seen as possessing no more than the virtue of simple information came to be seen as the product of distinctive personal visions. If this work seemed foreign to Alfred Stieglitz's concept of the art of photography, it fitted comfortably within the broader scheme of Beaumont Newhall, who in 1937 published the first edition of the first history of photography to be based on modern art-historical principles. During the same period the success of the Farm Security Administration's photography unit also helped undermine the idea that functional photography and photography as art were categorically discrete. In the changed circumstances the center of the problem had shifted; it was not necessary to defend Atget as the expression of a principle, but to understand him as an artist.

* * *

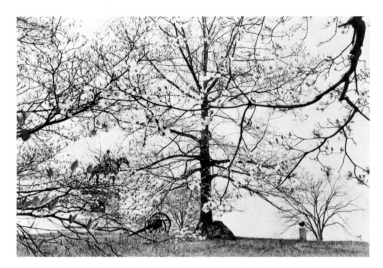

Lee Friedlander. *Untitled*. 1967. MoMA, purchase

Lee Friedlander. *Gettysburg*. 1974. MoMA, acquired with matching funds from the Lauder Foundation and the National Endowment for the Arts

The first demand that we make of a major artist, famous or nameless, is that subsequent artists be moved by his or her work, and take from it. This taking is different from stealing, for when the taking is done by an artist the work taken from is not diminished but enlarged, amplified by worthy progeny.

This endless chain of giving and taking and revising is too subtle for diagrams, and to speak of it at all is to risk vulgar pedantry. On the level of mechanics some evidence seems persuasive; Haydn said (I think) that he learned from Mozart how to score the woodwinds, but Haydn, even in his simpler time, could not know with confidence the sources of his intuitions. Even if useful experiences came single file, in clear chronological order, the artist might not know which worked to what end: which transition of color, which assemblage of words or sounds, which quality or suggestion, too tenuous for naming, might have fastened itself in his mind. We cannot identify the component parts of an artist's knowledge, much less know their working; yet we do know that what is new is nourished mainly by the old, or is a mutation of it, and we are inevitably as interested in the genealogy of our work as of ourselves.

To ask which contemporary photographers have been influenced by Atget is no more fruitful than to ask which contemporary painters have been influ-

enced by Matisse or Picasso or Mondrian. His work, like theirs, has long been a systemic part of the tradition; it and Atget are no longer wholly separable. If there are photographers who do not know Atget's name, they have nevertheless been influenced by his work. In this sense artistic influence can be seen as an organism that enters the body of tradition and affects its general nature. But in another sense influence is a function of knowledge, and the knowledge offered by a complex and radical artistic oeuvre is acquired slowly, as the body of work becomes more fully known, and selectively, according to the state of preparation of the artist who receives the message.

To consider a single case: The contemporary photographer whose work seems to me most clearly consonant with Atget's is Lee Friedlander. To press on from that undemonstrable claim to another marginally more susceptible to proof, it seems to me that Friedlander's work of the past dozen years has become increasingly informed by values similar to Atget's, and that these include a deep and forgiving affection for the truth, a love of both the shards and the new lumber of history, a native's identification with the values of his culture, and a deepening pleasure in the inexhaustible plasticity of photographic description.

In formal terms Friedlander's work has shifted during these years from a playful but insistent modernism

to a style that seems in comparison almost an unin-flected naturalism. The space of his pictures became deeper and less geometric in its divisions; his viewing distance became longer, and the assemblage of things that formed his subject more diverse; the gray scale of his pictures became subtler, and more responsive to the specific and evanescent light. These changes were coherent with a changing sense of his subject. Fried-lander's brilliant and original work of the sixties—surely one of the lasting achievements of the historic sensibility that was called Pop art—preserved an emo-tional distance between the photographer and his sub-ject, and more than a suggestion of ironic detachment. The Friedlander of those years was to a degree the old *flâneur* working a new boulevard. Beginning in the early seventies what was new in Friedlander's new work moved away from found cubism, from irony, from the glittering visual joke, and toward a more direct (and more complex) description of subjects that he found important and beautiful.

Nothing is proved by the fact that this change oc-curred in the years immediately following his expo-sure to a very substantial body of Atget's work, which he found deeply affecting.[68] The change might be explained as the natural result of Friedlander's own maturing, or by the confluence of that maturing with the present example of his friend Evans, or by con-tinued technical experiment that suggested new vari-eties of clarity and photographic beauty.[69] Neverthe-less, it is not credible that Friedlander's work should have remained unaffected by his experience of Atget. Friedlander has consistently declined to explain his work, but the quotation from Proust that he chose as epigraph to his 1978 volume can stand as a definition of his deepest fascination with his art. The quotation, elided here, says: "Apart from the most recent appli-cations of the art of photography . . . I know of noth-ing that can so effectively as a kiss evoke from what we believe to be a thing with one definite aspect, the hundred other things which it may equally well be since each is related to a view of it no less legitimate."[70]

* * *

The tracing of influence from artist to artist—record-ing the laying-on of hands from master to supplicant —is one way to study artistic movement. It is a tech-nique similar in its assumptions to a genealogical chart: change and continuity are expressed in the linear pas-sage (and revision) of privileged codes from a remoter to a nearer past. However useful such techniques, they do not exhaust the ways in which we can study change. In the case of artistic change, the direction of move-ment may be defined (or delimited) by the nature of a broadly perceived artistic problem, and by the historic state of that problem, which has been revised by all earlier workers who have proposed partial and pro-visional solutions. In the working-out of the problem the sequence of moves is not completely variable. In technical terms this is obvious enough; for instance, small cameras (and the kinds of pictures they propose) offered a very limited option before the development of satisfactory enlarging techniques, which in turn re-quired more sensitive printing papers than had been necessary earlier. But in expressive terms also, present possibilities arise from the creative criticism of existing works—successes or failures—and the freedom to in-vent lies within boundaries defined by our response to prior trials.[71]

One of the several sequences of linked endeavor to which Atget's work naturally belongs is a sequence that would include all photographs, or, more precisely, all photographs that might be said to be partial and provisional solutions to the problem of how to de-scribe the visible world by photographic recording of the images formed by cameras. Atget's work belongs to a period within that sequence that saw a great leap in photography's consciousness of the enormous rich-ness of significant subject matter. By the first decades of this century it was possible to believe—perhaps for the first time in the world's history—that *anything* was potentially the stuff of art: a segment of the side of a

Photographer unknown. *Grand Canyon*. c. 1905. Library of Congress

barn in sunlight, a machinist's lathe, the wheel of an automobile, a water storage tank, a stack of common china, a pepper. Such things could be converted into art not once but repeatedly, since the picture described not the Platonic but the contingent object, qualified by the moment and light and vantage point and by context—by the visual system that was defined by the picture's edges. Thus Stieglitz could photograph the clouds, or O'Keeffe, or the view from his window, endlessly. The real argument between the progressives and the conservatives perhaps had less to do with photographic purity vs. fake mezzotints than with closed vs. open views of what was the raw material of art.

From the acceptance of the contingent, the courting of luck and risking chaos, come those qualities Susan Sontag had in mind when she wrote that photography is the only art that is natively surreal,[72] referring not to the programs of the official Surrealist movement, but to the root sensibility that finds beauty and adventure in the disjunction of rational expectations. Sontag's observation is apposite; Man Ray did not photograph the juxtaposition of a sewing machine and an umbrella on a dissecting table until after the poet Isidore Ducasse had declared that such a conjunction would be beautiful,[73] but many photographers, mostly now faceless if not nameless, made many other

photographs no less foreign to a conventional sense of artistic order (see *Grand Canyon*, left). Perhaps only a photographer of high skill and immaculate taste to whose lot it falls to finish a sequence the thrust of which had been clearly sketched out—a Frederick Evans, or a Clarence White—can be trusted consistently to avoid such open-ended, one might say such pointless, pictures. As the sequence of which their work is a part nears completion, a White or an Evans becomes increasingly preoccupied with the perfection of the solution, and increasingly unable to reconsider the problem. The primitive, on the other hand—the artist whose work falls early in the sequence in which it belongs—is concerned primarily with the definition of his problem, and has little time for the more attenuated pleasures of refinement.

I know of no other photographer who responded with Atget's boldness and imaginative intelligence to the new perception of range and flexibility that first came to photography around the turn of the century. It was reported by friend and by detractor that Atget's early definition of his goal was to see and photograph everything.[74] On the basis of his work we might guess that by *everything* he meant everything that seemed to him to embody or reflect some part of what was vital in the tradition of his own culture. For twenty years, in the vigor of a robust middle age, he served this extravagant goal as a fanatic and indefatigable collector, an explorer, amateur, expert, and historian; a critic with a good mind and a clear eye and a deep affection for his subject. As age advanced it became clear that he would not after all see and photograph everything, and there comes into his work a new quality of elision, of eloquent compactness, that allows the late pictures to speak also for the places he did not see. Yet there is a sense in which the best of Atget's door knockers are as fine as his landscapes at Sceaux, more modest surely, but no less just, no less clearly described or less pertinent to his problem.

A substantial part of Atget's work has, in Man Ray's phrase, "a little dada or surrealist quality"; the work does challenge our received sense of the hierarchy of things, and of the normal relationships among them, but it does this in an unfamiliar way; Atget's

surrealism is not the one described by C. H. Waddington: "Where were we to turn for new values . . . ? We have seen the surrealist solution. Objects peeled of the coatings of emotion with which generations of human experience have covered them become ghosts of themselves, and can live a phantasmal life hovering on the lunatic fringe of consciousness, producing in men the vacuous mental excitement of paranoia."[75] Leslie Katz said that Atget's work "stresses the extremes of relation instead of disrelation."[76] In his work we are challenged by the unforeseen meaningfulness of ordinary things.

* * *

When Atget's work was first introduced to the larger world his critics wondered what kind of invisible man had made these pictures. Was he an unconscious medium, through which the culture of a time revealed itself; or an isolated, mutant poet, who had by luck stumbled on the aging tools with which he could describe his magic intuitions; or a prophet, a precursor of something to come; or an artist in a more familiar sense, one who had learned to use his recalcitrant craft in ways that it had not been used before, to amplify our sense of the potential meanings of life?

We now know his work much better than his early critics knew it, though still imperfectly, and we might now say that he was all of the things they thought he might be, but that he was finally the last, a conscious artist, who knew in his last years—as his command of his craft became bolder, and his vision of the world simpler, more trenchant and surprising— the high exhilaration of discovering a new kind of order within chaos.

But in recognizing Atget as an artist we should not deprive him of his simplicity, or of the humility that underlay his stubborn intractability, or of the blessing of his good luck, for it was simplicity that allowed him to be original, and humility that allowed him to work without applause, and good luck that brought him to his true craft.

Soon after setting up as a photographer Atget hung on his door a sign that bore the words "Documents pour Artistes." Too much has been made of the sign, which was a commercial announcement, not a philosophical statement, but what the sign said was true; Atget made descriptive photographs that served the needs of painters, and also of designers and fabricators, and *amateurs* of Paris, and scholarly institutions. If Atget expected these pictures to serve also his own need to do good work, this was not an original demand, but the traditional expectation of any self-respecting craftsman. If his definition of good work was original, and if it became more demanding and more radical as time went on, the fact need not have been obvious to Atget. It seems likely to us that he must have recognized in his last working years that the solution had outstripped the problem, but a genius might not have recognized this, and might have been right in seeing it so.

Jean Renoir said his father "was convinced that it was the world which was creating him, and that he was merely reproducing this life of ours, which enraptured him like a passage in a great symphony. . . . He only wanted to be a mechanism to take in and to give out, and to that end he was careful not to squander his strength, and to keep his vision clear and his hand sure. 'If it came from me alone, it would be merely the creation of my brain. And the brain, of itself, is an ugly thing. It has no value except what you put into it.'"[77]

It is not clear that an artist can give out only what he has taken in. But if Renoir's formulation is philosophically casual, it is morally thrilling. It makes us hope to see again artists not as gods but angels.

J.S.

29

Notes to the Essay

1. "Mlle Abbott porte un nom moitié ombre, moitié lumière: Bérénice. Elle expose sa mémoire délicieuse. Elle est le lieu d'une partie d'échecs entre la lumière et l'ombre.

 "Elles d'oiseau, oiseau des ils; Bérénice, oiseleur sans sexe, apprivoise l'ombre des oiseaux."

2. "Over the River," *Paris Times*, June 9, 1926.

3. *L'Art vivant*, Nov. 5, 1927. Florent Fels, editor of *L'Art vivant*, was also a member of the organizing committee of the Premier Salon Indépendant.

4. Berenice Abbott, d'Ora, Albin Guillot, Hoyningen-Huene, André Kertész, Germaine Krull-Ivens, Man Ray, and Paul Outerbridge.

5. Pierre Bost, *La Revue hebdomadaire*, June 16, 1928, p. 358.

6. Waldemar George, "Le Salon de la Photographie au Salon de l'Escalier," *Presse et Patrie*, June 11, 1928.

7. "Oldest and Newest in Photographs Contrasted in Unique Exhibit," *Chicago Tribune*, May 26, 1928.

8. F. [Florent] Fels, "Le Premier Salon Indépendant de la Photographie," *L'Art vivant*, June 1, 1928, p. 445. The Boulevard du Crime was the center of popular theater, famed not for its lawlessness but its melodramas; the Quinze-Vingts was an asylum for the blind; the Café Tortoni was favored by the more fashionable painters of the late nineteenth century, and their coteries.

9. Edmund Wilson, *Axel's Castle* (1931; New York and London: Charles Scribner's Sons, 1950), p. 11.

10. As listed in the catalog: Berenice Abbott, Anne Biermann, Robert Desmet, E. Gobert, André Kertész, Germaine Krull, Eli Lotar, E. L. T. Mesens, Moholy-Nagy, Man Ray, and Robertson.

11. Robert Desnos, "Eugène Atget," *Le Soir*, Sept. 11, 1928.

12. The clipping, from an unidentified newspaper, is included in Berenice Abbott's scrapbook (copy in Atget Archives, MoMA).

13. Roger Vailland, "Un Homme qui fit en trente ans dix mille photographies de Paris," *Paris-Midi*, Oct. 26, 1928.

14. F.L., "L'Exposition de la photographie à la Galerie 'l'Epoque,'" *Variétés* (Brussels), Nov. 15, 1928.

15. "To Exhibit Atget Photos," *New York Post*, Apr. 15, 1929.

16. *XIXe Salon de l'Escalier* (1er Salon Indépendant de la Photographie) (Paris: Comédie).

17. Waldemar George, "L'Art photographique," *La Presse*, Oct. 15, 1928.

18. The other members listed in this catalog were the poet Jean Prévost and the filmmaker René Clair, though the latter apparently took no part in its work (letter to Maria Morris Hambourg, July 13, 1979; Atget Archives, MoMA).

19. M. F. Agha, "Whistler's Hippopotamus," *Vogue*, Mar. 15, 1937, p. 138.

20. Ibid.

21. Paul Rosenfeld, "Paris, the Artist," *The New Republic*, Jan. 28, 1931, pp. 299–300.

22. In a letter to the *New York Times* (Feb. 28, 1932), Herbert J. Seligmann responds to a review by E.A.J. (Edward A Jewell?), which said that Stieglitz was "carrying on the great tradition of the Frenchman Atget and others." Seligmann says that "as a matter of history and fact, this statement is false. As a characterization of Stieglitz photography it is imbecile. [Stieglitz's work is to be placed] not in this category of picture making but of spiritual fact."

23. Pierre Mac Orlan, "L'Art littéraire d'imagination et la photographie," *Les Nouvelles littéraires*, Sept. 22, 1928. The same essay was printed under the title "La Photographie" as the introduction to the 1928 exhibition at the Galerie L'Epoque in Brussels.

24. Pierre Mac Orlan, "La Photographie et le fantastique social," *Les Annales*, Nov. 1, 1928, pp. 413–14.

25. Note 23.

26. Pierre Mac Orlan, "Photographie: Eléments de fantastique social," *Le Crapouillot*, Jan. 1929, pp. 3–5.

27. Note 24.

28. Note 14.

29. Note 11.

30. Walter Benjamin, "Short History of Photography," *Artforum*, Feb. 1977, p. 51. Translated by Phil Patton from "Kleine Geschichte der Photographie," *Literarische Welt*, Sept. 18 and 25, Oct. 2, 1931.

31. *Atget: Photographe de Paris* (Paris: Henri Jonquières, 1930; also New York: E. Weyhe, 1930) and *Atget: Lichtbilder* (Leipzig: Verlag Henri Jonquières, 1930).

32. Benjamin, "Short History of Photography," pp. 46–51.

33. Amédée Ozenfant, *Foundations of Modern Art*, trans. John Rodker (1928; new American edition, New York: Dover Publications, 1952), p. 224.

34. Fernand Léger, "The Machine Aesthetic, the Manufactured Object, the Artisan and the Artist," trans. Charlotte Green, in *Léger and Purist Paris* (London: The Tate Gallery, 1970), p. 91. Originally published in the *Bulletin de L'Effort Moderne*, nos. 1 and 2 (Jan. and Feb. 1924).

35. W. B. Yeats, "A General Introduction for My Work" (1937), in *Essays and Introductions* (New York: Collier Books, 1968), p. 522.

36. Walter Benjamin, "The Work of Art in the Age of Mechanical Reproduction" (1936), in *Illuminations*, trans. Harry Zohn, introd. by Hannah Arendt (New York: Harcourt, Brace and World, 1969), pp. 220, 226.

37. Ibid., p. 228.

38. Perhaps the most systematic effort to define procedures that would allow photographs to conform to standard rules of evidence, and thus make them a more reliable tool for social science, is that proposed by John Collier, Jr., in *Visual Anthropology: Photography as a Research Method* (New York: Holt, Rinehart and Winston, 1967). Collier's method has not proved useful to photographers in the field.

39. "A Prospectus for a New Magazine" (New York: Time, Inc., 1936).

40. Waldemar George, "Photographie: Vision du monde," in a special number of *Arts et métiers graphiques*, Mar. 15, 1930, pp. 134–35. Waldemar George was a prolific critic who wrote on all of the visual arts of the modern period. In *Foundations of Modern Art* (note 33) Ozenfant cites George for having "brought to Cubism his generous enthusiasm and passionate courage" (p. 80).

41. Berenice Abbott, "Eugène Atget," *Creative Art*, Sept. 1929; reprinted in *Photography: Essays and Images*, ed. Beaumont Newhall (New York: The Museum of Modern Art, 1980), pp. 235–37.

42. Max Planck, "Phantom Problems in Science," a 1946 lecture reprinted in *Scientific Autobiography and Other Papers*, trans. Frank Gaynor (New York: Philosophical Library, 1949), pp. 52, 53.

43. Some two thousand negatives dealing with specifically historical subjects were given or sold to the Monuments Historiques by André Calmettes, Atget's executor.

44. Walker Evans, "The Reappearance of Photography," *Hound and Horn*, Oct.–Dec. 1931, pp. 125–28.

45. *Walker Evans*, introd. by John Szarkowski (New York: The Museum of Modern Art, 1971), p. 16.

46. James Stern, "Walker Evans," *London Magazine*, Aug.–Sept. 1977, p. 5.

47. Walker Evans, *American Photographs*, with an essay by Lincoln Kirstein (New York: The Museum of Modern Art, 1938; reissued 1962). The pictures to which I refer are reproduced in the first edition as pls. 4 and 8 of Part I and pl. 1 of Part II; in the 1962 edition on pages 17, 25, and 113.
 It should be noted that few photographers consistently date their negatives at the time they are developed, and fewer still did so in 1930. When a date is requested for a publication or an exhibition, the photographer reluctantly dredges a year from his memory —often, in all innocence, the wrong year. In *Walker Evans at Work* (New York: Harper and Row, 1982), John Hill and his collaborators have, on the basis of painstaking research, assigned new dates to some of Evans' work, including *Political Poster, Massachusetts Village* (listed above as pl. 4, Part I, or as p. 17), to which they assign the date 1930–31.

48. Quoted in Stern, "Walker Evans" (note 46).

49. Ansel Adams, *The Fortnightly* (San Francisco), Nov. 6, 1931, p. 25. The review is more fully quoted in *The Work of Atget*, Vol. I, p. 24.

50. Ansel Adams, *The Fortnightly* (San Francisco), Dec. 18, 1931, pp. 21–22.

51. Zigrosser was director of the Weyhe Gallery from 1919 to 1940, and was thus familiar with Atget's work from the date of his first American show there in 1930. From 1941 to 1963 Zigrosser was Curator of Prints and Drawings at the Philadelphia Museum of Art.

52. Edward Weston, "Daybooks, December 27, 1930," in *The Daybooks of Edward Weston: Volume III, California*, ed. Nancy Newhall (New York and Rochester: Horizon Press with the George Eastman House, 1966), p. 201.

53. Ibid., p. 202.

54. Edward Weston, letter of Apr. 18, 1938, in *Edward Weston: Photographer*, ed. Nancy Newhall (Rochester: Aperture, 1965), p. 58.

55. Bill Brandt, letter of Apr. 8, 1978, to Maria Morris Hambourg; Atget Archives, MoMA. Brandt adds: "René Clair was very possibly much inspired by Atget when he made his film 'Sous les toits de Paris' in 1930. I am sure Atget is the greater artist of the two."

56. Henri Cartier-Bresson, introd. to *The Decisive Moment: Photography by Henri Cartier-Bresson* (New York:

Simon and Schuster with Editions Verve, 1952), un-paged.

57. Paul Hill and Tom Cooper, "Interview: Man Ray," *Camera*, Feb. 1975, p. 39.

58. Jean Renoir, *Renoir, My Father* (Boston and Toronto: Little, Brown and Co., 1962), pp. 32, 93–94.

59. Ibid., pp. 31–32.

60. Note 57, pp. 39–40.

61. Man Ray, letter quoted by Minor White in "Eugene Atget, 1856 [*sic*] –1927," *Image*, Apr. 4, 1956, p. 77.

62. According to his friend Ernest Halberstadt, Rehyer suffered a stroke while returning to New York from California by train and was taken from the train some-where en route. Halberstadt believes that the suitcase containing the manuscript of "Tin" was lost at that time. (From the transcript of a taped conversation be-tween Halberstadt, Peter Bunnell, and others at The Museum of Modern Art, c. 1969; Atget Archives, MoMA).

63. A portion of Rehyer's research notes on Atget, some very difficult to decipher, are included in the Atget Archives, MoMA. They are the gift of Ernest Halberstadt.

64. Reyher's notes for the Addison Gallery exhibition of 1948 were reprinted in *Photo Notes*, the official publi-cation of the Photo League (Fall 1948). The quotations included here are from that source.

65. *Eugène Atget, 1856* [*sic*] *–1927*, directed by Harold Becker, with music by Erik Satie (distributed by The Images Film Archive, Mamaroneck, N.Y.).

66. John Fraser, "Atget and the City," *The Cambridge Quarterly* (Summer 1968), pp. 199–233.

67. Ibid., p. 210.

68. Friedlander studied closely and with pleasure the first survey of the Abbott-Levy Collection at The Museum of Modern Art in 1969–70 and the smaller 1972 exhi-bition, "Atget's Trees."

69. While continuing to refine his personal photographic technique, Friedlander in the mid-sixties acquired the negatives of E. J. Bellocq, which encouraged him to explore the printing procedures in common use during Atget's (and Bellocq's) time.

70. Marcel Proust, "A Visit from Albertine," *The Guer-mantes Way*, in *Lee Friedlander: Photographs* (New City, N.Y.: Haywire Press, 1978), unpaged.

71. I hope that the thought here does not do too much violence to the ideas stated with such precision by George Kubler in *The Shape of Time: Remarks on the History of Things* (New Haven and London: Yale Uni-versity Press, 1962).

72. Susan Sontag, "Melancholy Objects," *On Photography* (New York: Farrar, Straus and Giroux, 1977), pp. 51–52.

73. Le Comte de Lautréamont [Isidore Ducasse], *Les Chants de Maldoror* (Paris and Brussels, 1874), p. 290.

74. Atget's friend André Calmettes and an anonymous model who was angered by photography's absorption of the model's traditional role both emphasize the al-most omnivorous character of Atget's early ambitions. See "A Biography of Eugène Atget" by Maria Morris Hambourg, Vol. II of this work, pp. 15–16 and note 43.

75. C. H. Waddington, *The Scientific Attitude* (West Dray-ton, Middlesex: Penguin Books, 1943, 2nd ed.), p. 59.

76. Leslie Katz, "The Art of Eugène Atget," *Arts Maga-zine*, May–June 1962, p. 35.

77. Jean Renoir, op. cit., pp. 220–21.

Plates

Pl. 1. Voiture, Bois de Boulogne. (*1910*)

Pl. 2. Voiture, fiacre. (1899)

Pl. 3. Luxembourg. (1899)

Pl. 4. Café, avenue de la Grande Armée. (1924–25)

Pl. 5. Le Dôme, boulevard Montparnasse. Juin 1925

41

Pl. 6. Coin, boulevard de la Madeleine, 8ᵉ. Juin 1925

Pl. 7. Place Dancourt, Théâtre de Montmartre. Juin 1925

43

Pl. 8. Boulevard de Bonne-Nouvelle. Mai 1926

Pl. 9. Boulevard de Bonne-Nouvelle. (1926)

Pl. 10. Boutique journaux, rue de Sèvres. (1910–11)

Pl. 11. Pompes funèbres. (*1910*)

Pl. 12. Bitumiers. (1899–1900)

Pl. 13. Bitumiers. (1899–1900)

Pl. 14. Paveurs. (1899–1900)

Pl. 15. Commissionnaire. (1899–1900)

Pl. 16. Marchand de paniers. *(1899–1900)*

Pl. 17. Marchand de paniers de fil de fer. (1899–1900)

Pl. 18. Marchand abat-jours. (1899–1900)

Pl. 19. Rémouleur. (1899–1900)

Pl. 20. Porteuse de pain. (1899–1900)

Pl. 21. Mitron. (1899–1900)

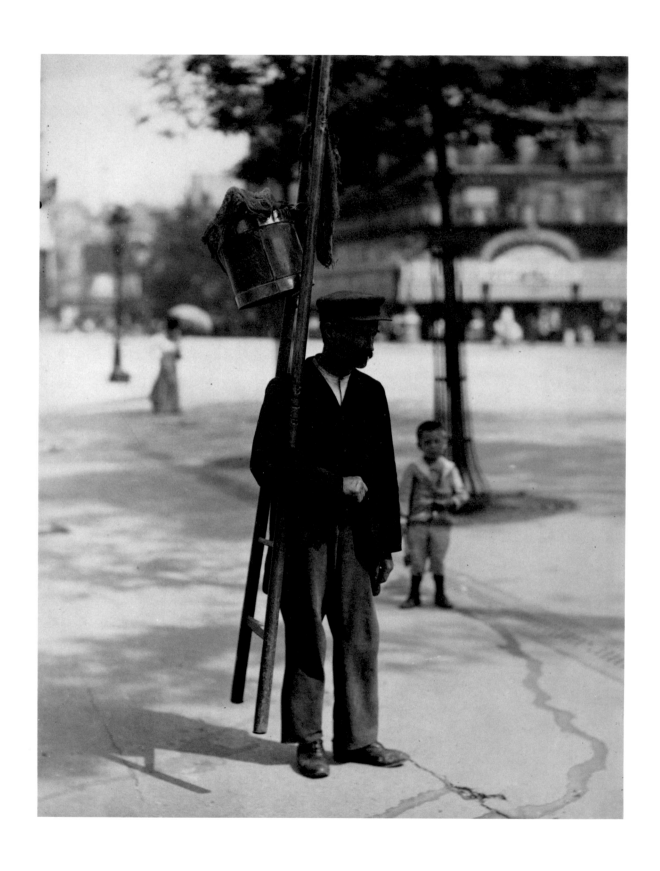

Pl. 22. Untitled [window washer]. (1899–1900)

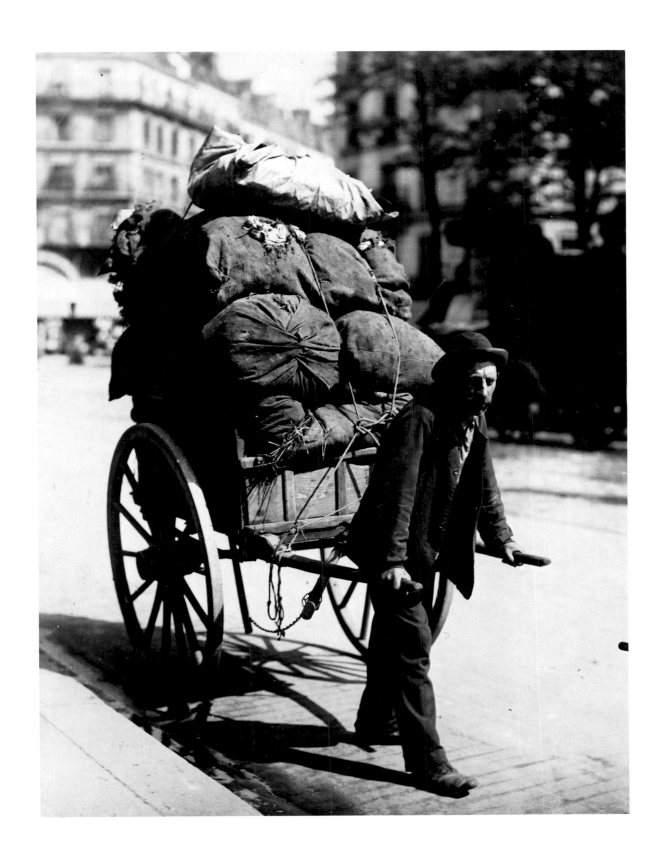

Pl. 23. Untitled [ragpicker]. (1899–1900)

Pl. 24. Tombereau. (1910)

Pl. 25. Camion. (*1910*)

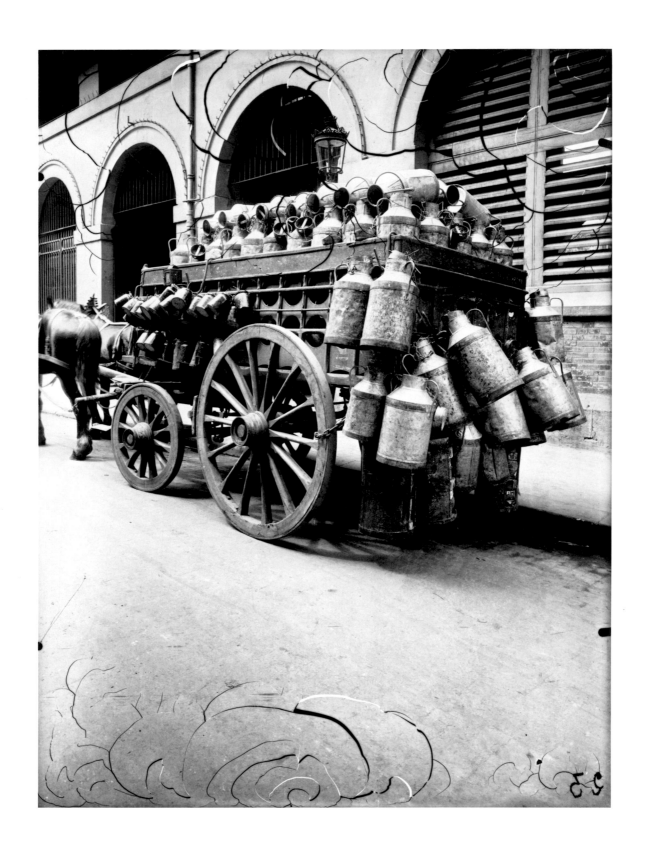

Pl. 26. Laitière. (1910)

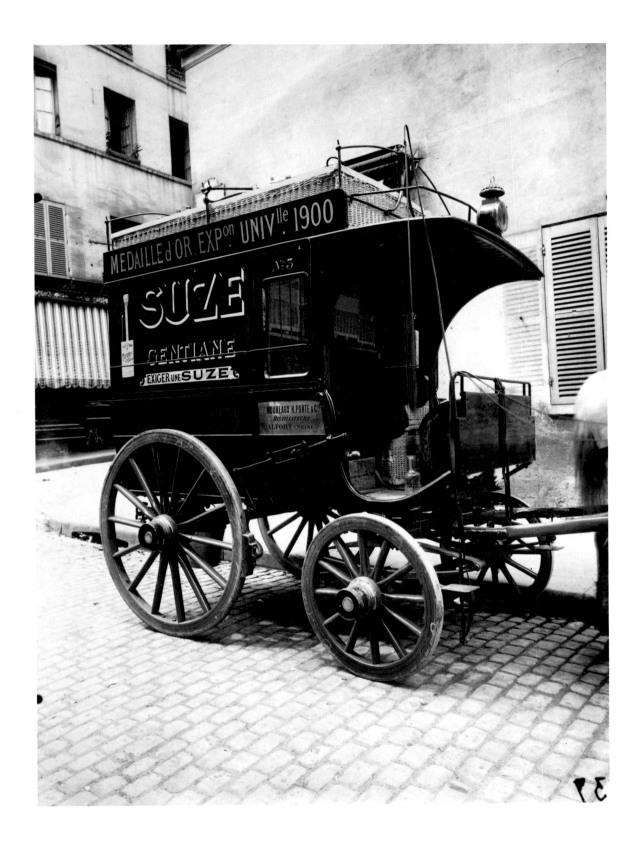

Pl. 27. Voiture. (1910)

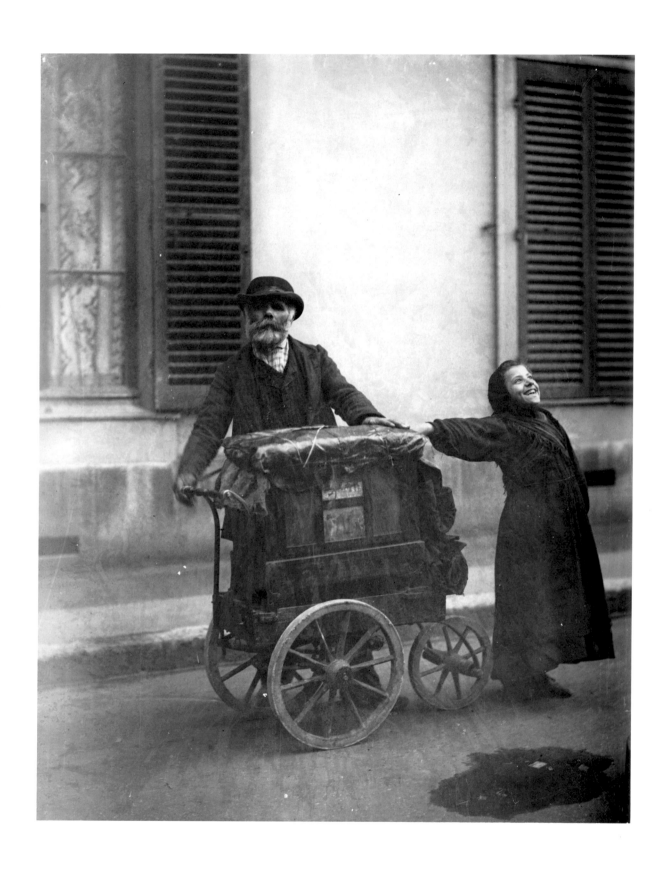

Pl. 28. Joueur d'orgue. (1898–99)

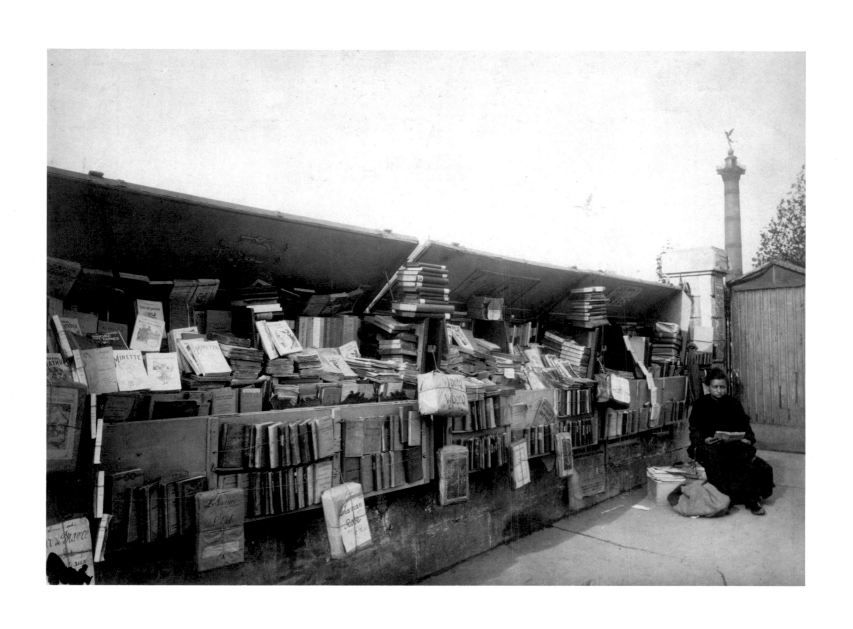

Pl. 29. Place de la Bastille, bouquiniste. (1910–11)

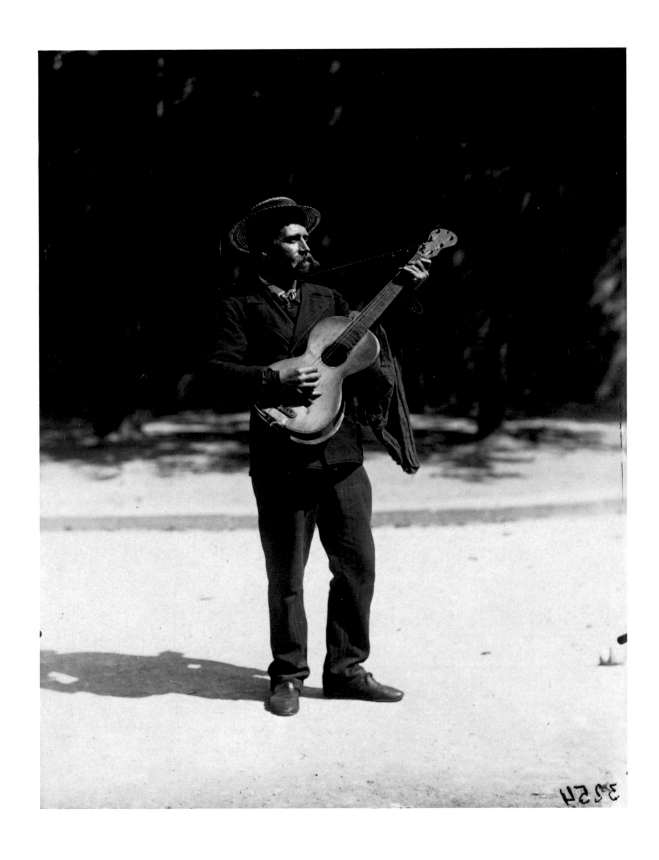

Pl. 30. Joueur de guitare. (1899–1900)

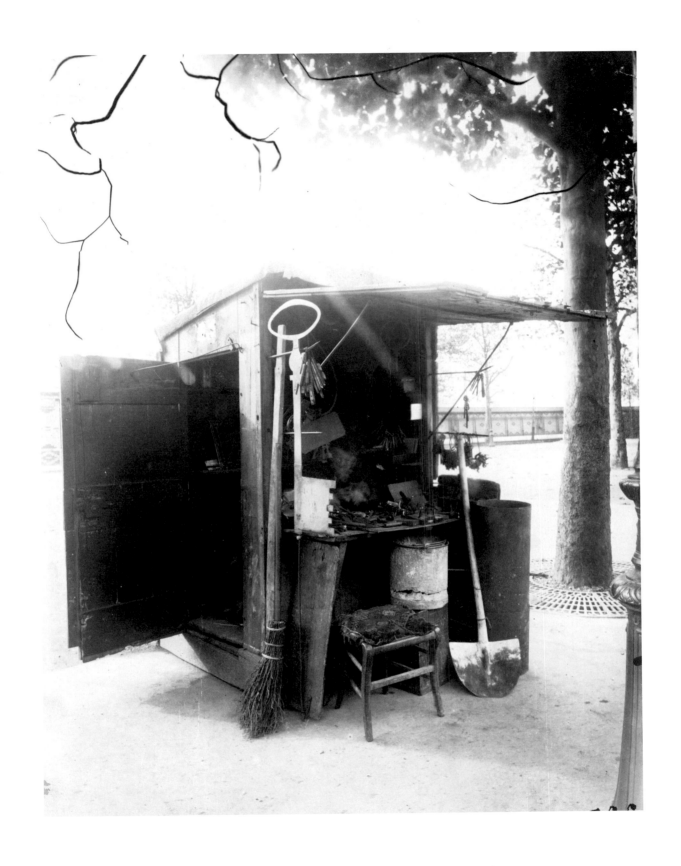

Pl. 31. Boutique clefs, quai de la Rapée. (1910–11)

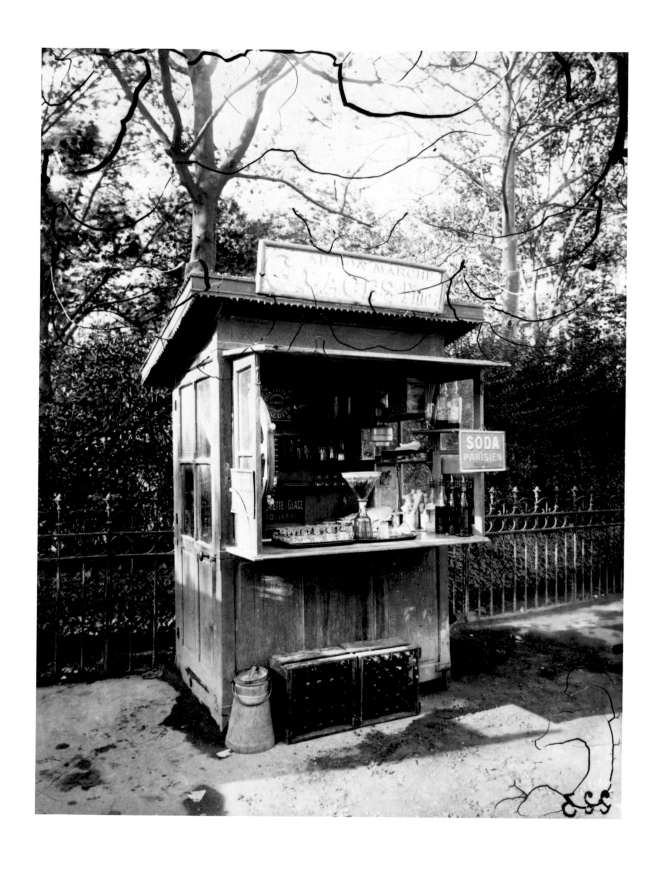

Pl. 32. Boutique, square du Bon Marché, rue de Sèvres. (1910–11)

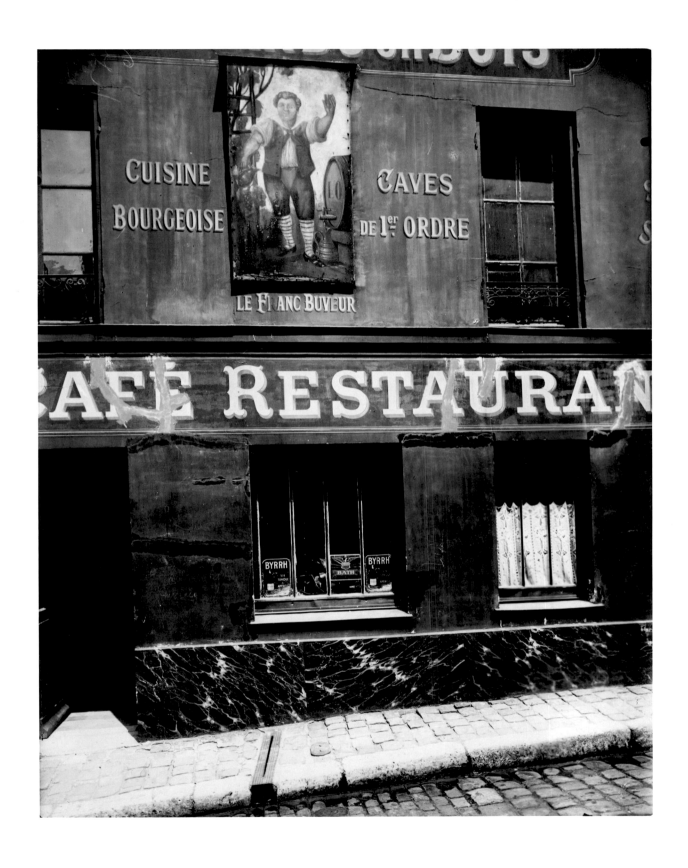

Pl. 33. Rue St-Vincent, Montmartre. Juin 1922

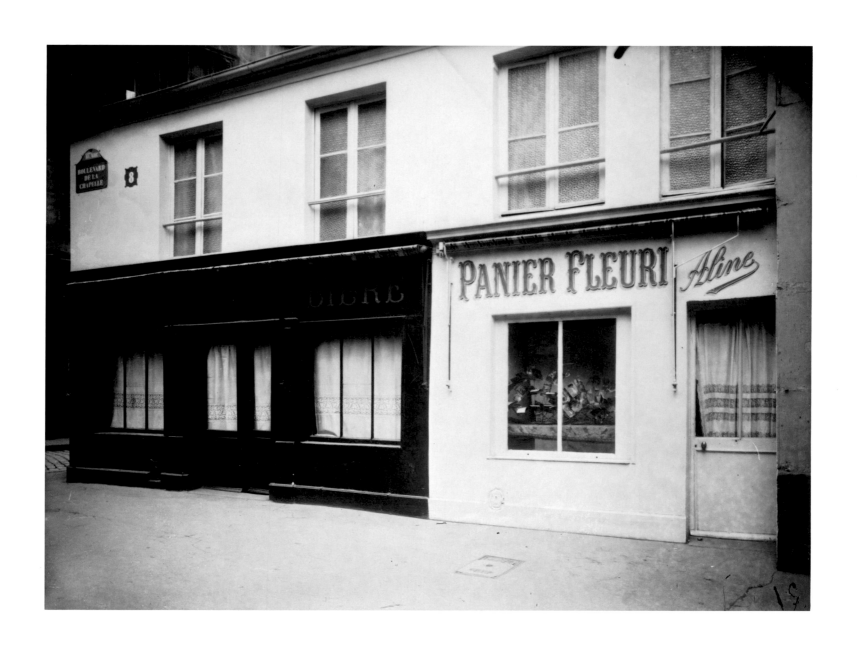

Pl. 34. Boulevard de la Chapelle, 18ᵉ. (1921)

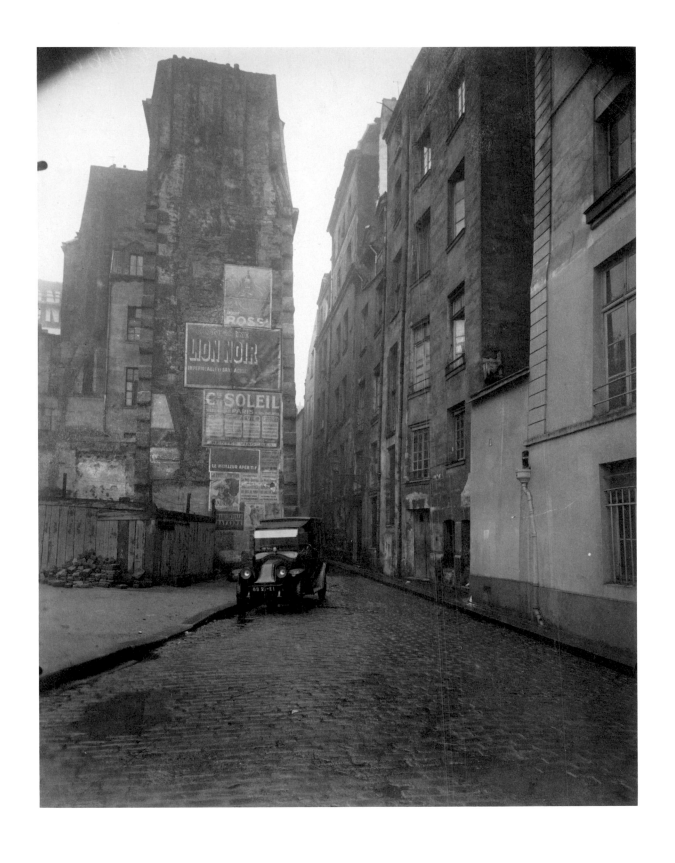

Pl. 35. La rue de Nevers. Mars 1924

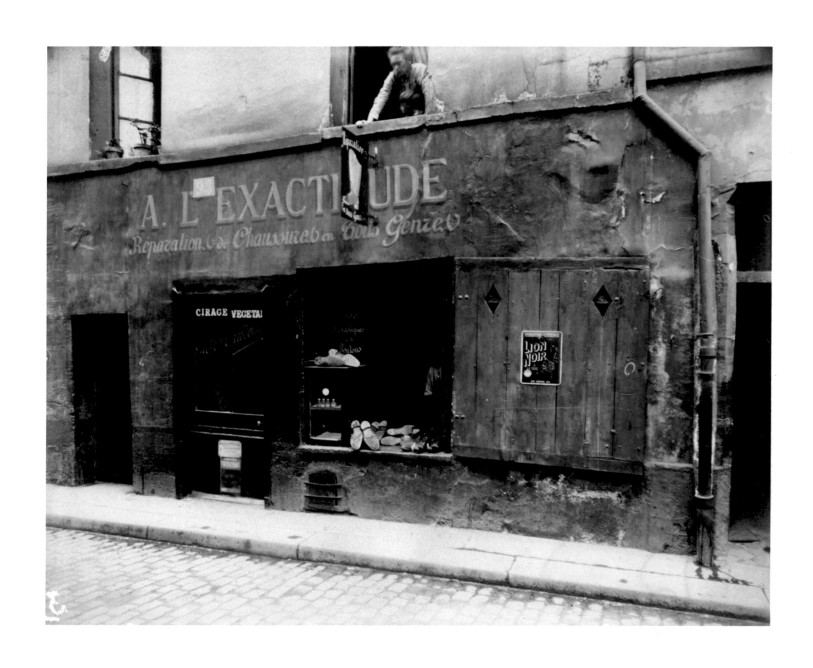

Pl. 36. Boutique, 93 rue Broca. (1912)

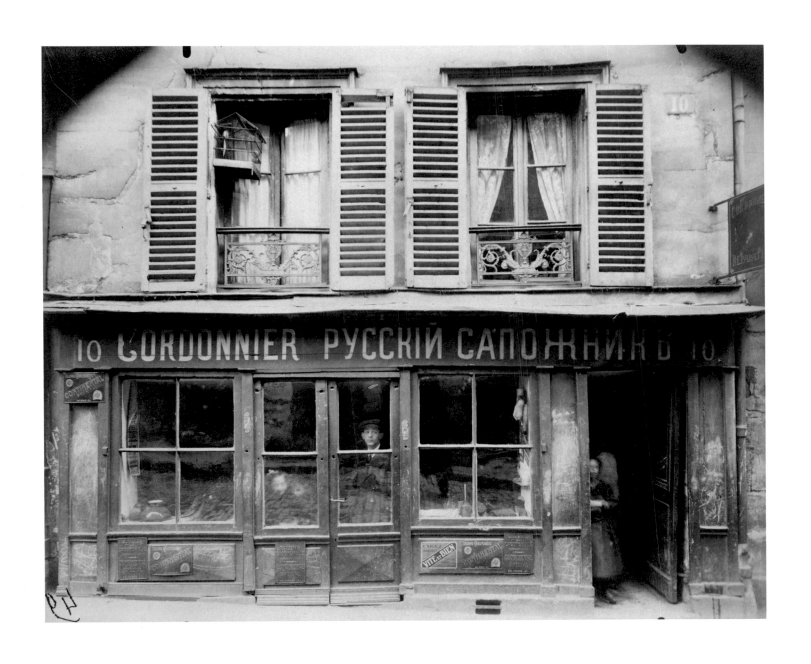

Pl. 37. Vieille boutique, rue des Lyonnais 10. (1914)

Pl. 38. Boutique aux Halles. (1925)

Pl. 39. Boutique aux Halles. (1925)

Pl. 40. Avenue des Gobelins. (1926–27)

Pl. 41. Avenue des Gobelins. (1926–27)

Pl. 42. Rue Mouffetard. (1926)

Pl. 43. Rue Mouffetard. (1926)

Pl. 44. Impasse Samson, Châtillon. (1922)

Pl. 45. Saint-Denis, canal. (1925–27)

Pl. 46. Cour, 3 ruelle des Reculettes. (*1926*)

Pl. 47. Poterne des Peupliers, zoniers. (1913)

Pl. 48. La Bièvre, Gentilly. 1901

Pl. 49. La Bièvre, Gentilly. 1901

Pl. 50. Bassin de la Villette. (1914–25)

Pl. 51. Zoniers, Porte de Choisy. (1913)

Pl. 52. Porte d'Asnières, Cité Trébert. (1913)

Pl. 53. Romanichels, groupe. (1912)

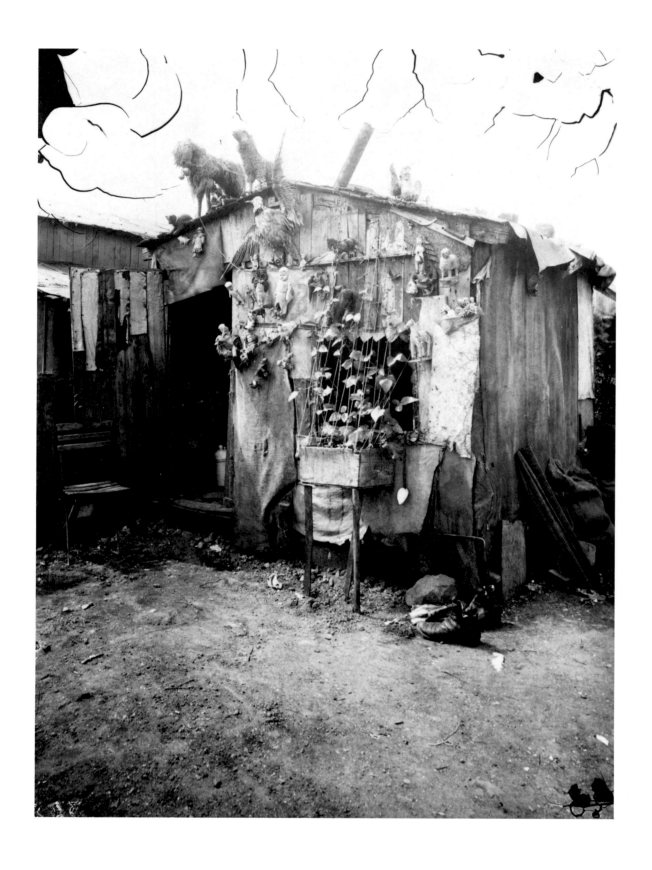

Pl. 54. Villa d'un chiffonnier. (1912)

Pl. 55. Porte d'Ivry, villa des chiffonniers. (1910)

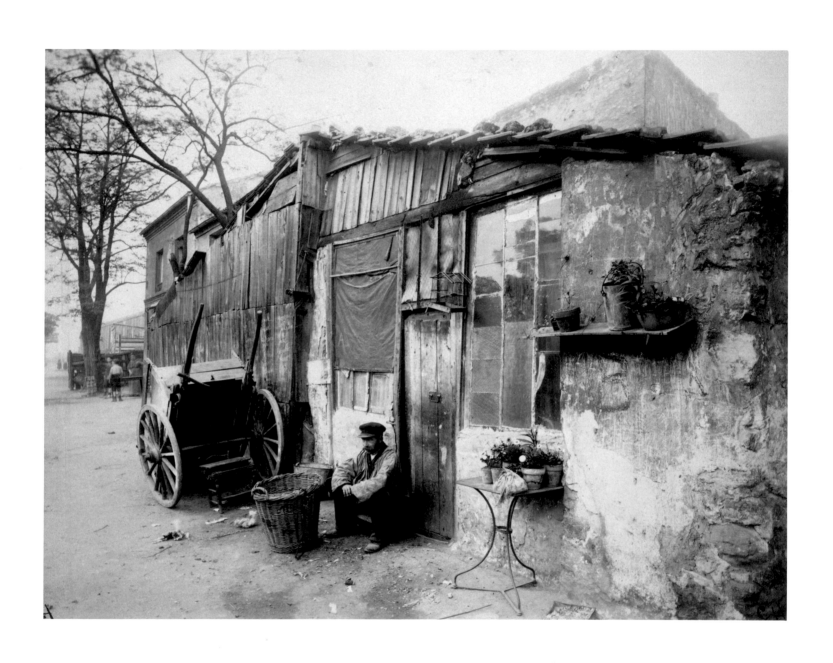

Pl. 56. Villa d'un chiffonnier, boulevard Masséna. (1910)

Pl. 57. Boulevard de la Villette 122. (1924–25)

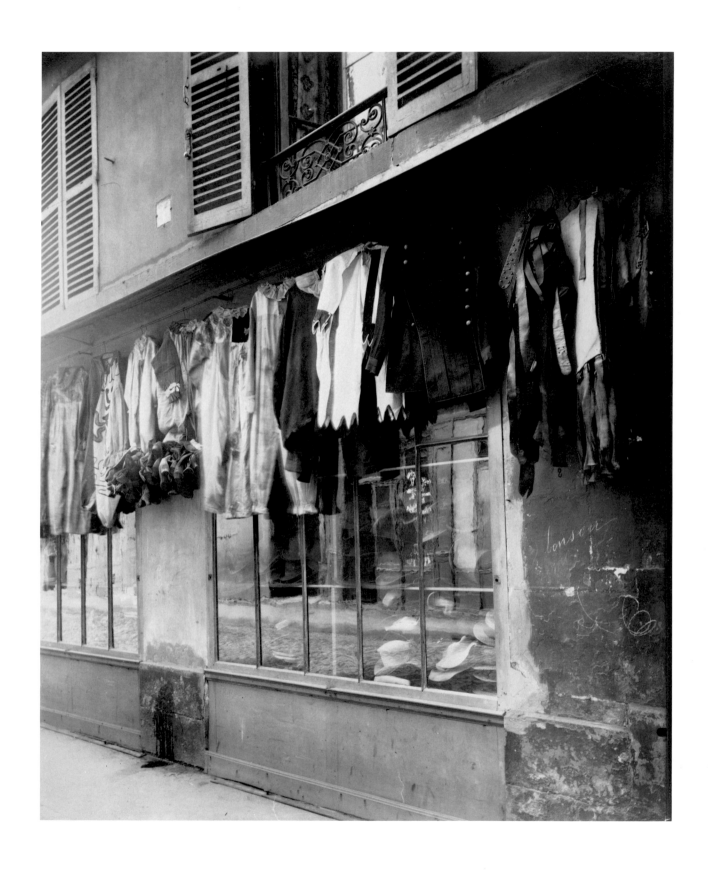

Pl. 58. Boutique, 2 rue de la Corderie (Temple). (1910–11)

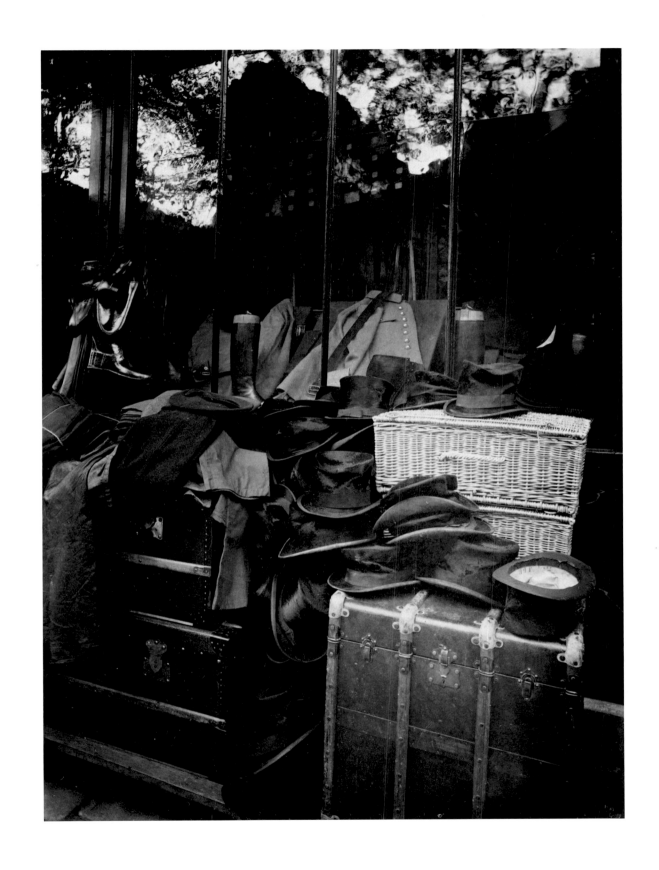

Pl. 59. Boutique, Marché aux Halles. Juin 1925

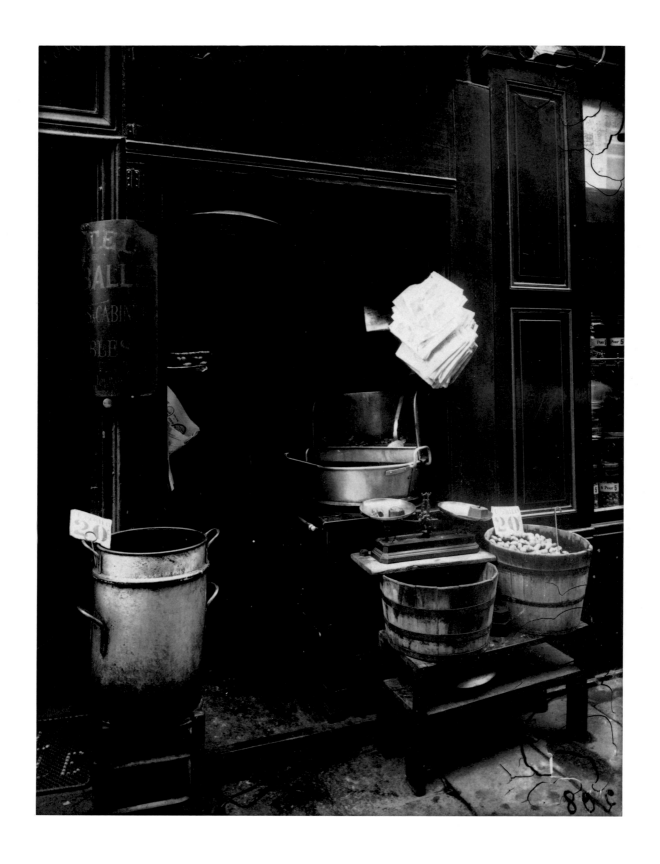

Pl. 60. Fritures, 38 rue de la Seine. (1910)

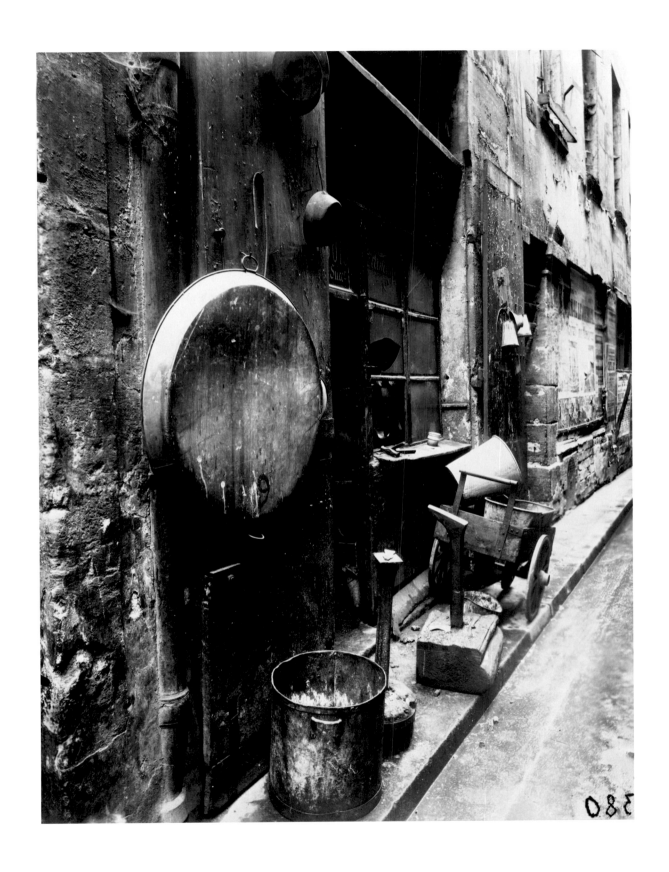

Pl. 61. Rue de La Reynie, étameur. (1912)

Pl. 62. Rue Pigalle, à 6 h. du matin en avril 1925

Pl. 63. Marchand de vin, 15 rue Boyer. (1910–11)

Pl. 64. Moulin Rouge. (*1926*)

Pl. 65. Boutique automobile, avenue de la Grande Armée. (1924–25)

Pl. 66. Cabaret de L'Enfer, boulevard de Clichy 53. (1910–11)

Pl. 67. Versailles, maison close, Petite Place. Mars 1921

Pl. 68. Rue Asselin. (1924–25)

Pl. 69. 14 rue Mazet. (1925)

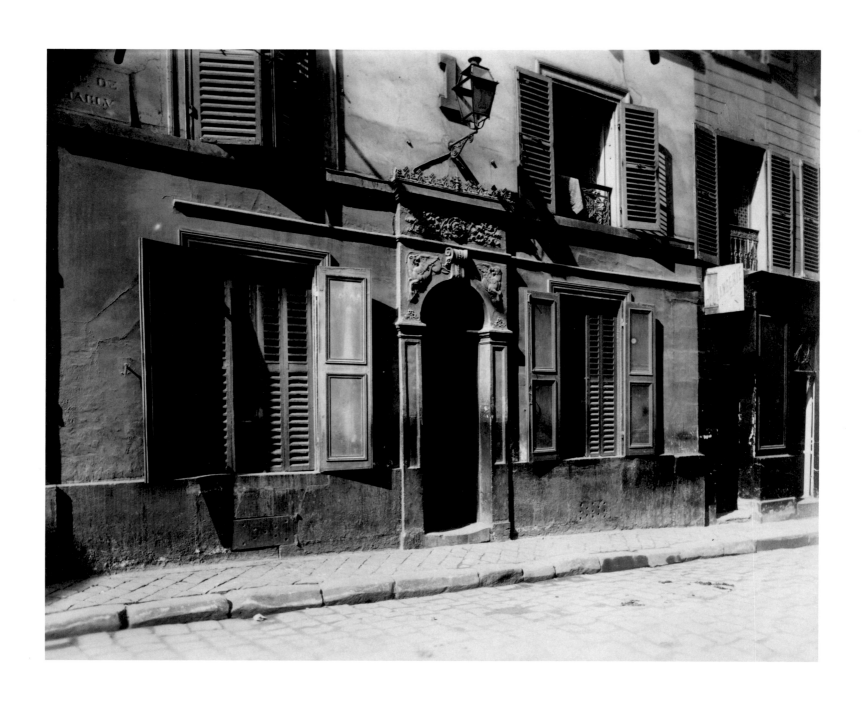

Pl. 70. Versailles, maison close, Petite Place. Mars 1921

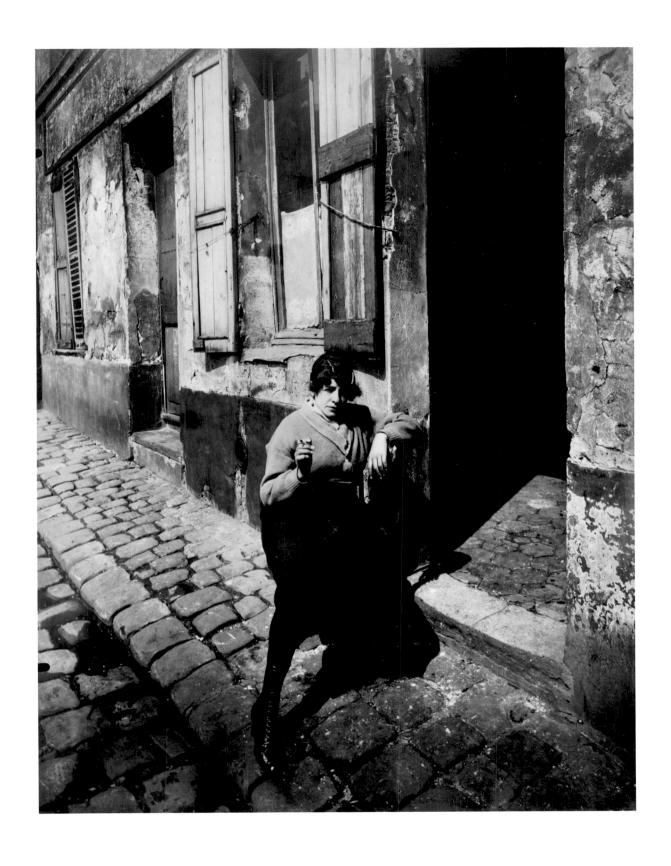

Pl. 71. La Villette, fille publique faisant le quart, 19ᵉ. Avril 1921

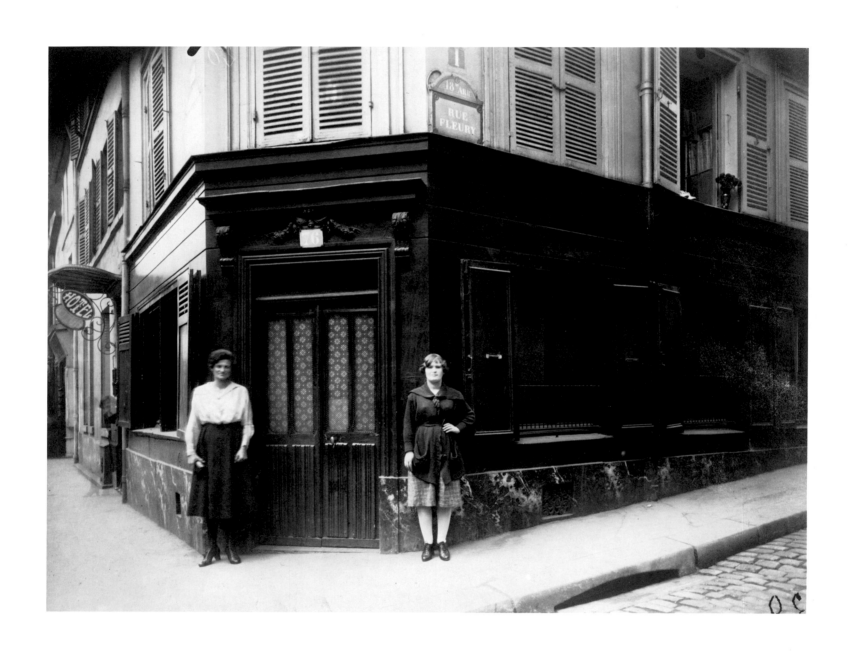

Pl. 72. Coin, boulevard de la Chapelle et rue Fleury 76, 18ᵉ. Juin 1921

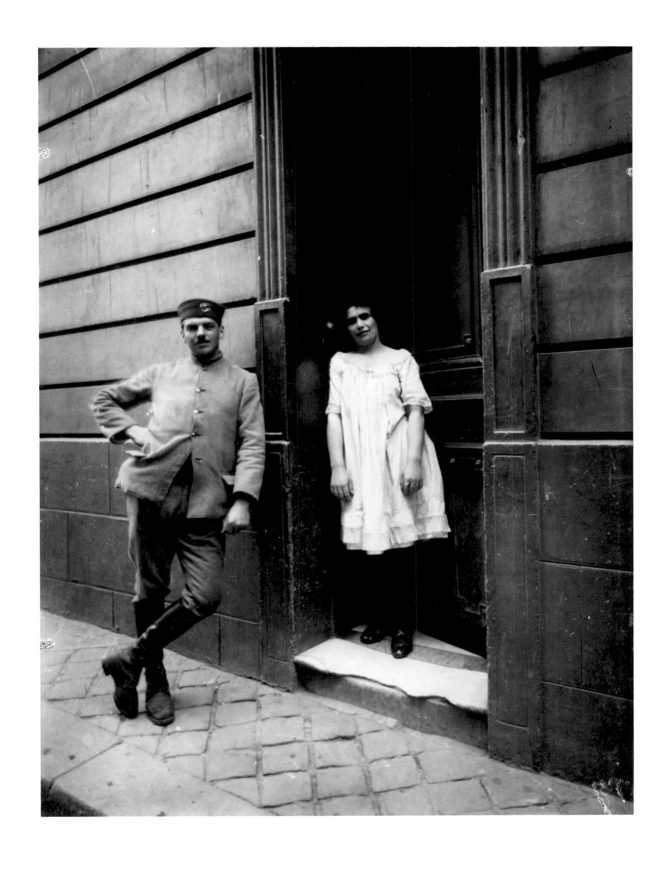

Pl. 73. Verscilles, femme et soldat, maison close. Mai 1921

Pl. 74. La Villette, rue Asselin, fille publique faisant le quart devant sa porte, 19ᵉ. 7 mars 1921

Pl. 75. Maison à Versailles. (1921)

Pl. 76. Cour, 7 rue de Valence. Juin 1922

Pl. 77. Boulevard Saint-Denis. Mai 1926

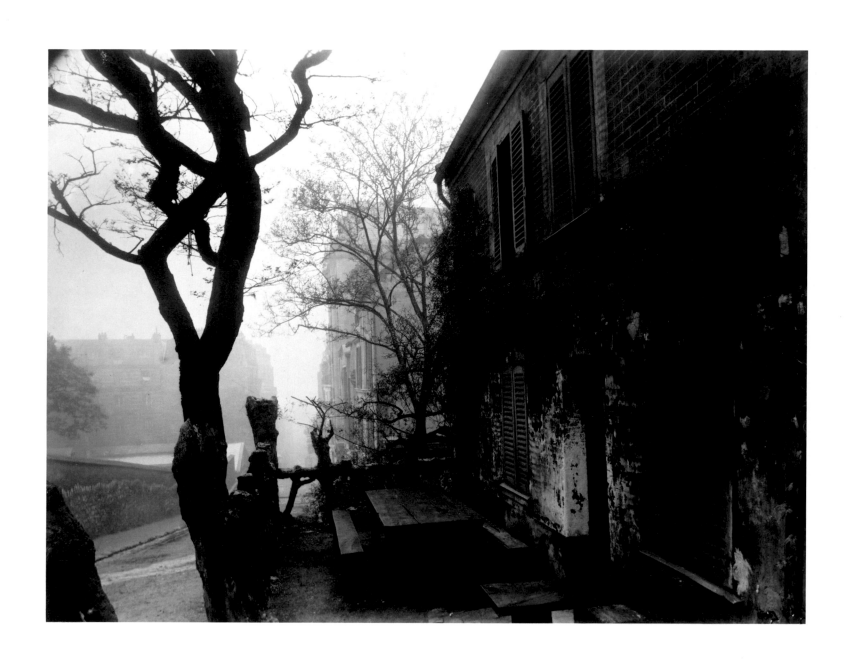

Pl. 78. Rue des Saules, Auberge du Lapin Agile. Avril 1926

114

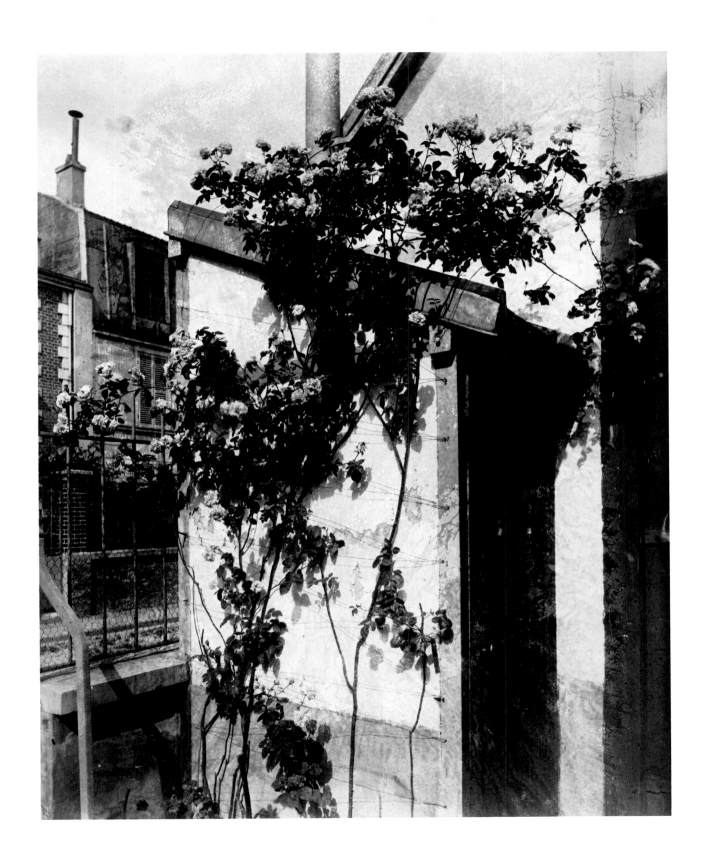

Pl. 79. Rosier grimpant. (1910 or earlier)

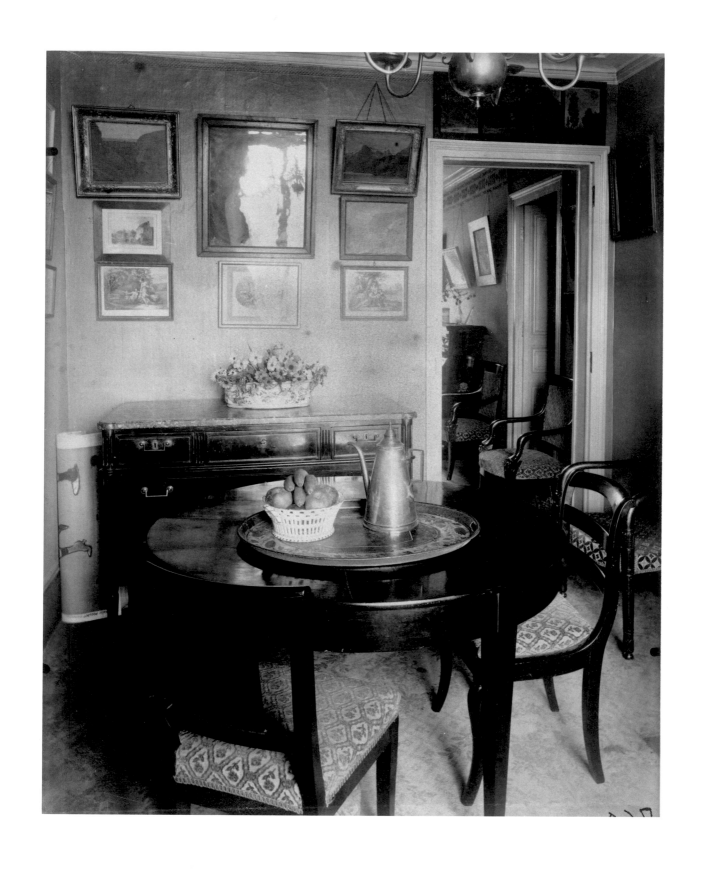

Pl. 80. Intérieur de M^r *A., industriel, rue Lepic. (1910)*

116

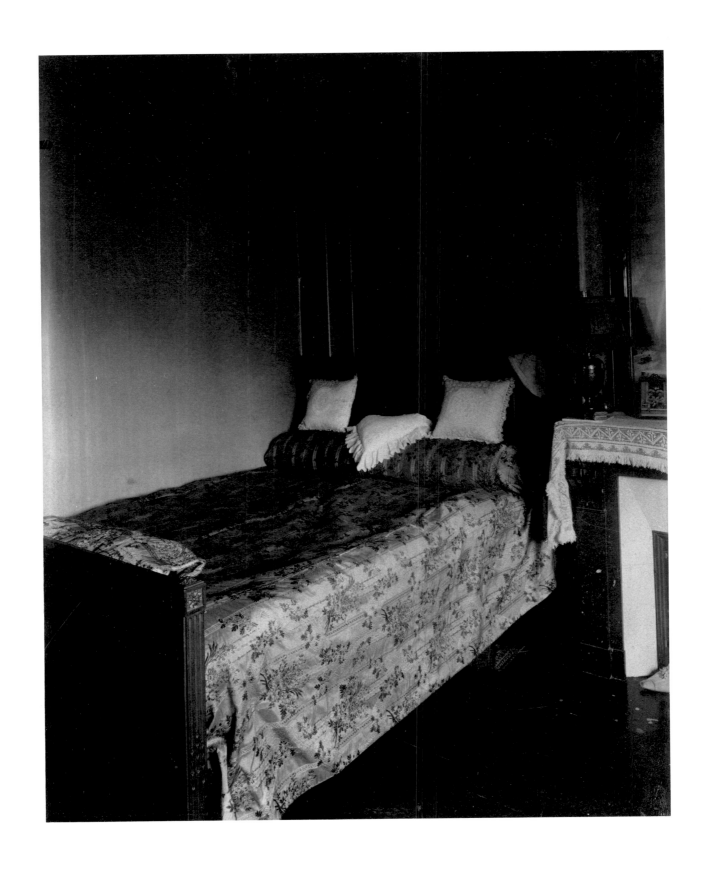

Pl. 81. Intérieur de M^r C., décorateur, rue du Montparnasse. (1910)

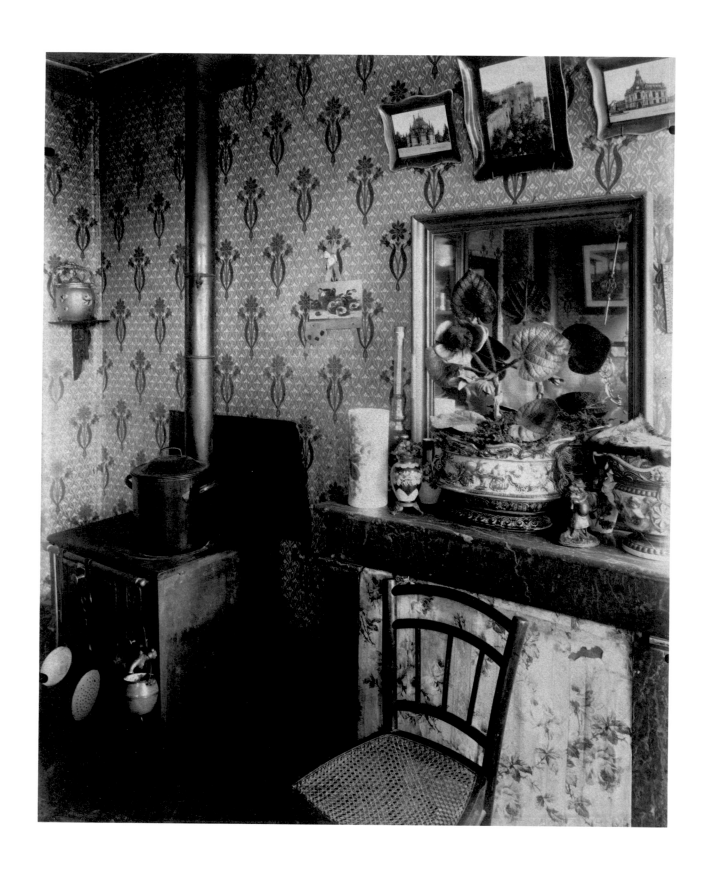

Pl. 82. Intérieur ouvrier, rue de Romainville. (1910)

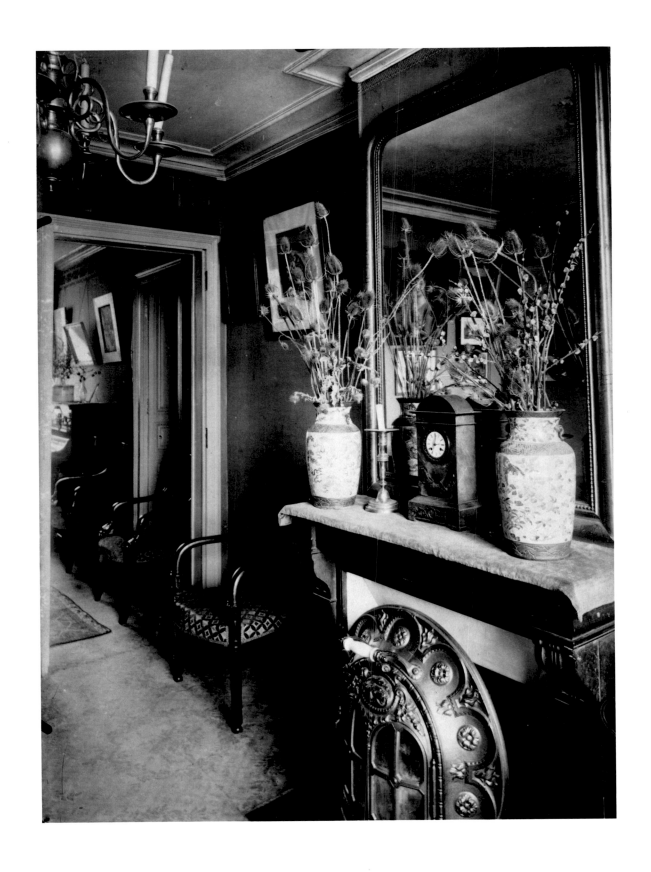

Pl. 83. Intérieur de M^r A., industriel, rue Lepic (Montmartre). (1910)

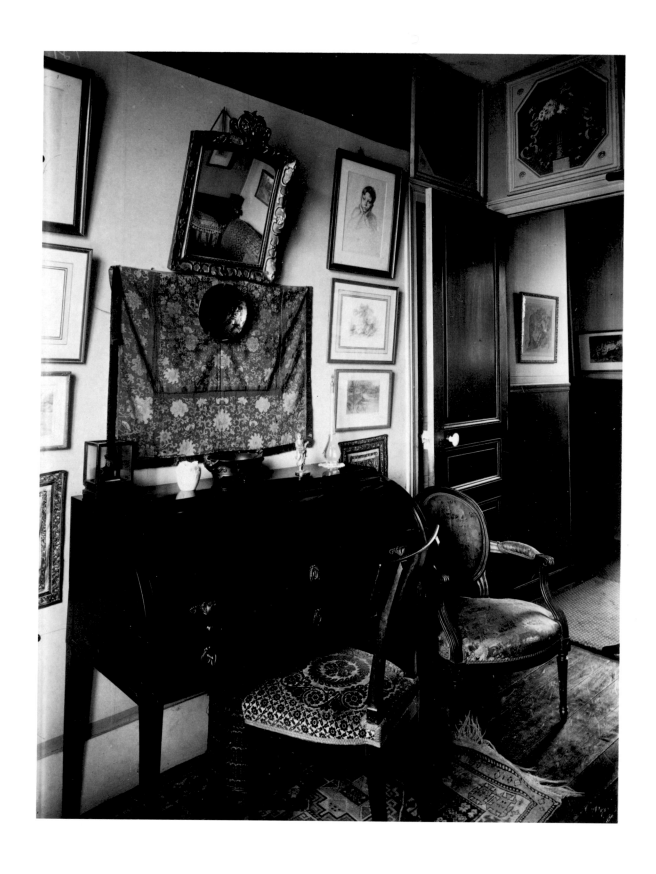

Pl. 84. *Intérieur de M*r *C., décorateur appartements, rue du Montparnasse.* (1910)

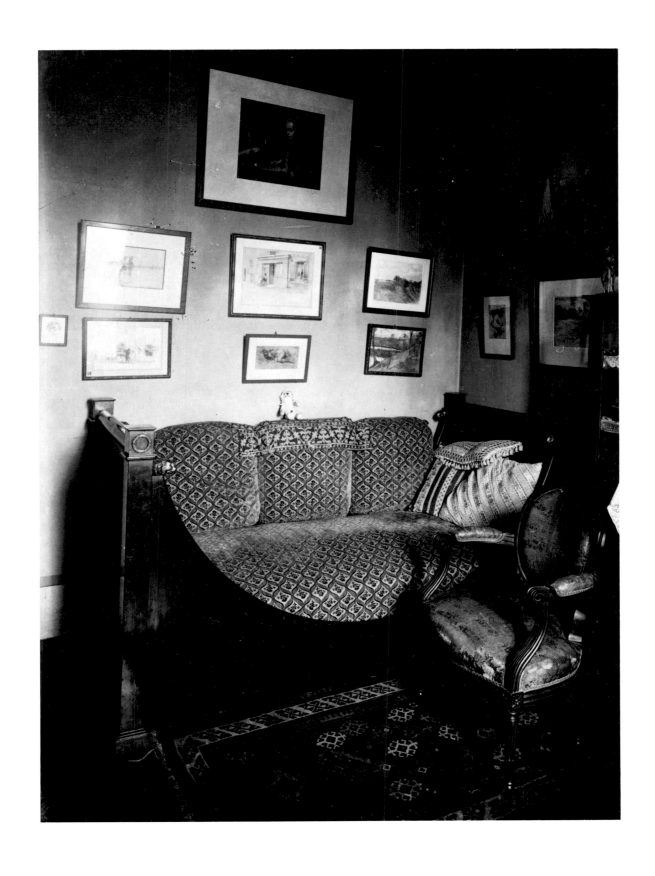

Pl. 85. Intérieur de M^r C., décorateur appartements, rue du Montparnasse. (1910)

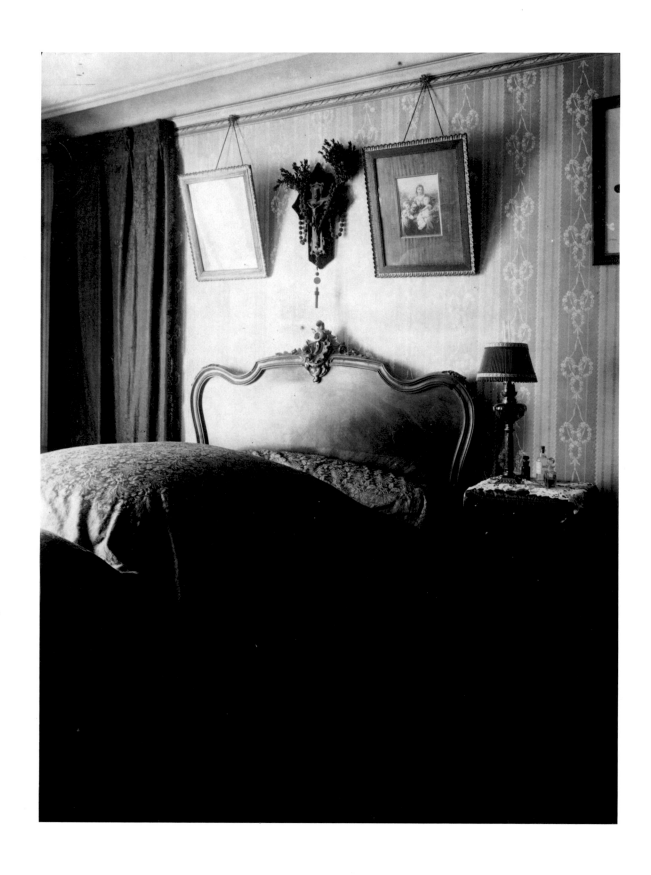

Pl. 86. Intérieur de M^{me} D., petite rentière, boulevard du Port Royal. (1910)

Pl. 87. Intérieur de M^{me} D., petite rentière, boulevard du Port Royal. (1910)

Pl. 88. Intérieur de M^r C., décorateur appartements, rue du Montparnasse. (1910)

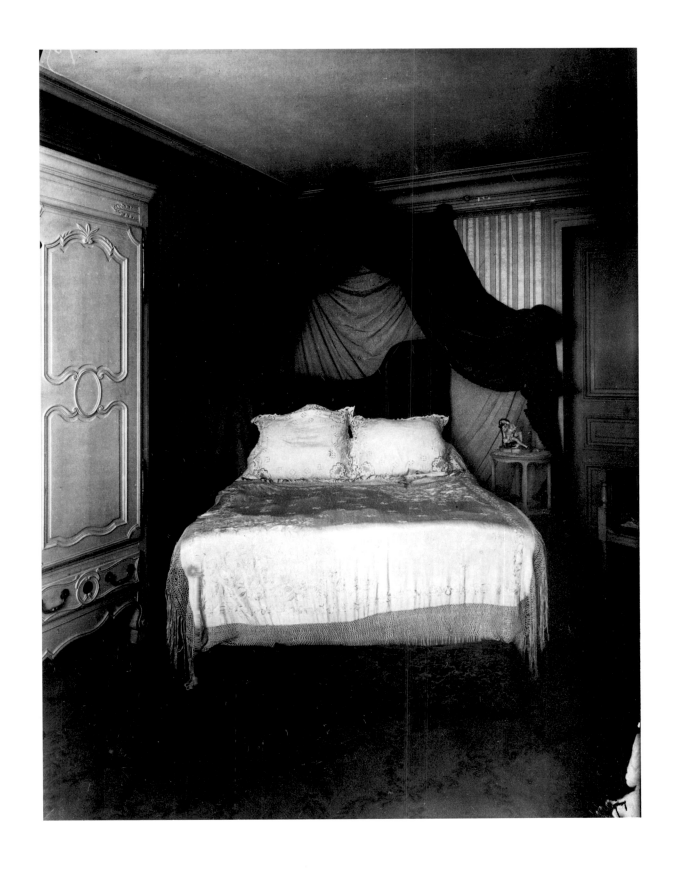

Pl. 89. Intérieur de Mᴿ F., négociant, rue Montaigne. (1910)

Pl. 90. Naturaliste, rue de l'Ecole de Médecine. (1926–27)

Pl. 91. *Le salon de M*^{me} *C., modiste, place Saint-André-des-Arts.* (1910)

Pl. 92. Boulevard de Strasbourg, corsets. (1912)

Pl. 93. Coiffeur, boulevard de Strasbourg. (1912)

Pl. 94. Magasins du Bon Marché. (1926–27)

Pl. 95. Coiffeur, Palais Royal. (1926–27)

Pl. 96. Coiffeur, avenue de l'Observatoire. (1926)

Pl. 97. Magasin, avenue des Gobelins. (1925)

Pl. 98. Magasins du Bon Marché. (1926–27)

Pl. 99. Untitled [toupee shop, Palais Royal]. (1926–27)

Pl. 100. Magasin, avenue des Gobelins. (1925)

Pl. 101. Magasin, avenue des Gobelins. (1925)

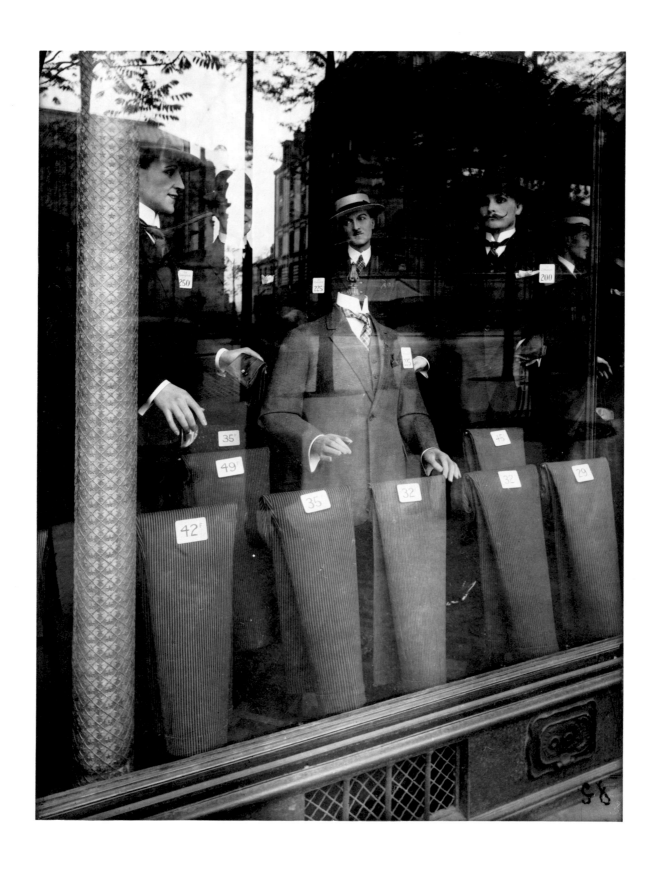

Pl. 102. Avenue des Gobelins. (1925)

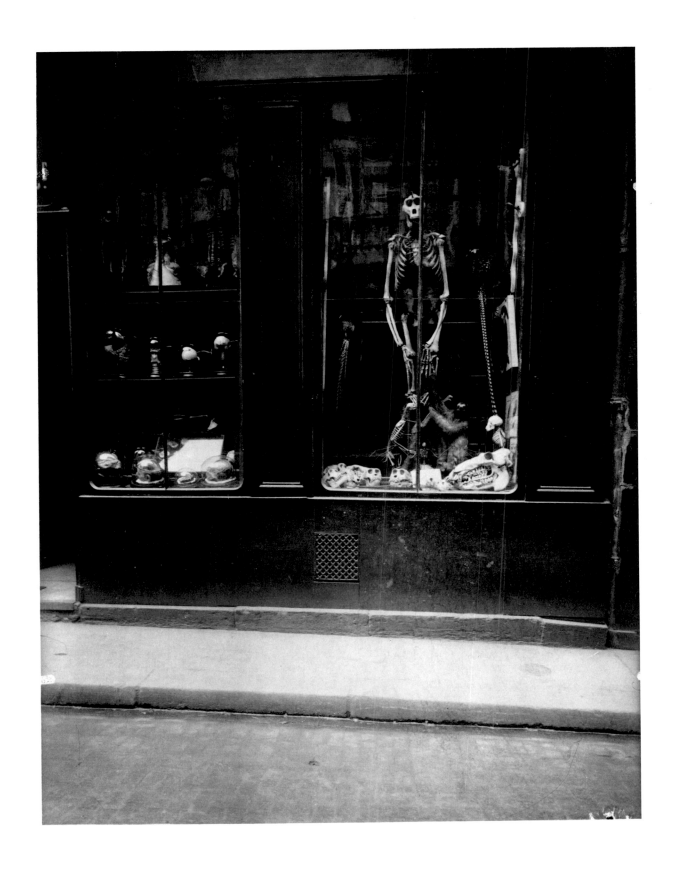

Pl. 103. Naturaliste, rue de l'Ecole de Médecine. (1926–27)

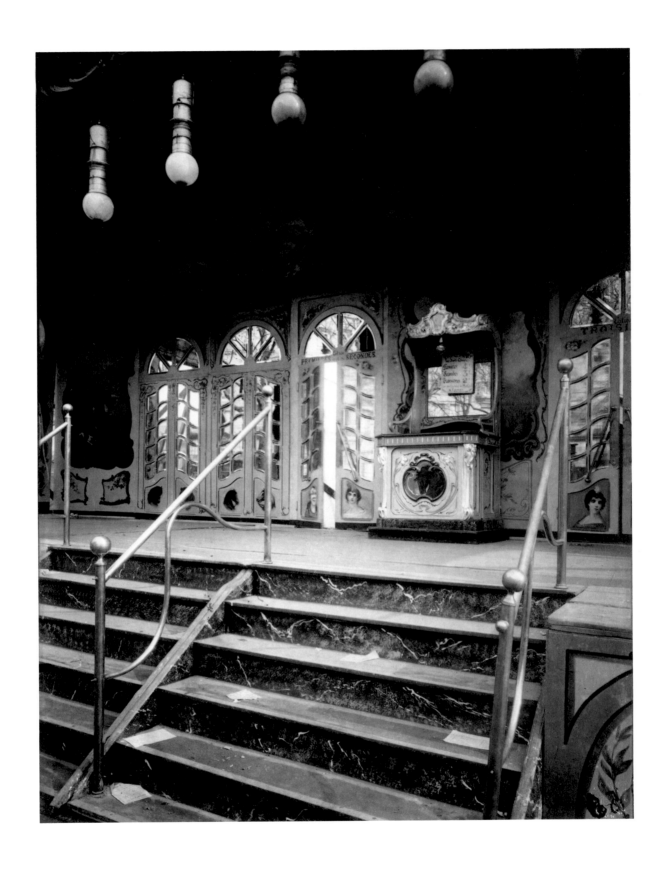

Pl. 106. Fête de Vaugirard. (1925)

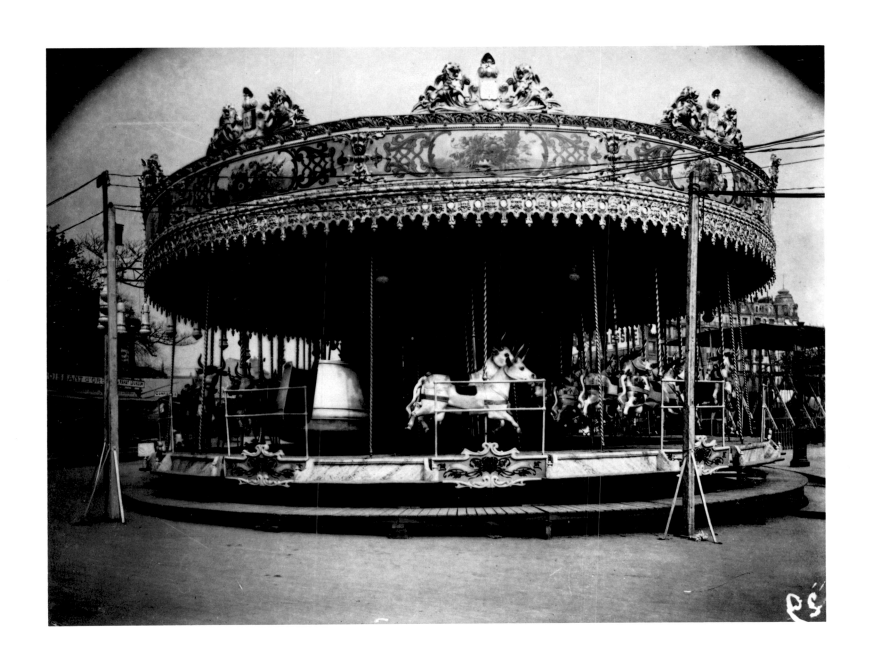

Pl. 107. Foire. (1923)

Pl. 114. Fête du Trône. (1924)

Pl. 115. Fête du Trône. (1925)

151

Pl. 116. Fête du Trône. (1925)

152

Notes to the Plates

THE CONTENT of this final volume of *The Work of Atget* concerns the contemporary life of the city, especially (directly or tangentially) its commercial life, and the ways its people earned their livings. The pictures reproduced here are selected primarily from three discrete sequences, totaling some nine hundred pictures, that Atget made during the early, middle, and late periods of his career. Although numbered separately, each sequence bore the title Picturesque Paris, and each considered aspects of the ordinary, vernacular life that during the nineteenth century had gradually become a central concern of the literary and visual arts.

Broadly considered, most of the subjects represented here were the common property of many commercial photographers of Atget's day, and before them of a long line of artists who worked in other media to describe the same homely issues. (The *petits métiers* had been a traditional subject of popular art even before Edme Bouchardon's *Les Cris de Paris* of 1746; Atget's series on *voitures* may be seen as related in its function to Diderot's encyclopedia; his attention to the Punch and Judy shows in the parks and the traveling street fairs was anticipated by many popular printmakers of the nineteenth century.) Like most artists of consequence, Atget is remarkable not because he began with a new idea, but because through his work he constructed one. He brought to inherited problems independence of mind, seriousness of character, and an original sensibility. He began by trying to describe clearly his knowledge of the ordinary, important facts of his world, and he never found it necessary to revise this view of the problem. To the end of his life, the question continued to yield extraordinary answers.

It is perhaps finally irrelevant to ask how much of Atget's Paris is Paris, and how much Atget. As with Bishop Sully and Le Vau and Hugo and Haussmann and Baudelaire and all the others, we remember Atget because we can no longer clearly distinguish between his private intuitions and history.

*　　　　*　　　　*

The following notes to the plates and related illustrations (figures) that reproduce photographs by Atget provide the following information: title, date, Atget negative number, and Museum of Modern Art acquisition number. The titles are those he wrote on the back of his prints or in the paper albums in which he stored them. Where inconsistencies occur in the form of the title of a given subject, we have for the sake of clarity sometimes adopted the most common form. Clarifications or additions to Atget's titles are enclosed in brackets. Dates in parentheses have been attributed on the basis of the dating charts reproduced in Volume III; those without parentheses were recorded by Atget on the prints or in the albums. The letters that precede Atget's negative numbers indicate the series to which the picture belongs; these letters do not appear on Atget's plates or prints. (See the explanation of the dating charts, Vol. III, p. 181.) All Atget photographs reproduced in this volume are from prints by Atget, unless identified by the legend Study Collection print, 1978, or by the abbreviation CAW (Chicago Albumen Works). Acquisition numbers beginning "1.69 . . ." indicate prints from the Abbott-Levy Collection, acquired by the Museum in 1968; those ending in ".50" were acquired from Berenice Abbott in 1950. All the Atget prints reproduced in this volume are contact prints reproduced from plates measuring 18 × 24 cm.

J.S.

Fig. 1

Fig. 2

Fig. 3

Frontispiece. *Le fiacre, avant les pneus.* (1898.) ve:59,
 formerly PP:3067. MoMA 1.69.1954
Pl. 1. *Voiture, Bois de Boulogne.* (1910.) ve:53. MoMA 1.69.1967
Pl. 2. *Voiture, fiacre.* (1899.) ve:64, formerly FP:2169. MoMA
 Study Collection 84.36. Print by CAW, 1984

The Egyptians had wheeled vehicles, and from our vantage point it might seem that carriage-making by Atget's time must have been a static craft, repeating time-tested solutions. In fact, men rode horseback until relatively recent times. In 1550 there were three primitive carriages in Paris, one owned by the Queen, one by Diane de Poitiers, and one by René de Laval, who was too obese for a horse to bear. Rapid progress was made during the reign of Louis XIV, but it was not until the beginning of the nineteenth century that Obadiah Elliot patented the elliptical spring, which provided the basis for lighter, modern models and a rapid series of design improvements that continued well into this century. In 1910, the year in which Atget made plate 1, the Encyclopaedia Britannica noted that after the death of Prince Albert, full-dress carriages of the most impressive sort had declined in number, but that there were hopes of a revival.

The driver in plate 2 is recommended by his headgear. The Paris Baedeker of 1904 says, "Cabs whose drivers wear *white hats* are usually the most comfortable and the quickest." The guide also states that the cab fare is one and one-half francs (plus tip) per trip anywhere within the fortifications, or two francs per hour. The latter charge "is very moderate, and is on that account not popular with the drivers. Although they are legally bound to conform to it they are always ready with some evasive pretext."

One would guess that Atget's series on wheeled vehicles constituted a profitable part of that aspect of his business that catered to the needs of illustrators and painters, for whom it was important that the appropriate vehicle be described in a technically correct way, even if broadly indicated. Business considerations aside, the fact that Atget's father and grandfather had been carriage makers may have added to Atget's interest in the project and made him more than ordinarily alert to the great advances in carriage design that occurred during his lifetime.

It appears that Atget eventually made seventy-three pictures for his *voiture* group. The earlier of these were first cataloged in the first part of his Picturesque Paris series, but were renumbered in 1910 to form a discrete subseries.

Pl. 3. *Luxembourg.* (1899.) AP:3630. MoMA 1.69.1442
Fig. 1. Brassaï (Gyula Halász). *Chair, Tuileries Garden.*
 (Before 1938.) Courtesy Madame Brassaï

Over a period of more than a quarter-century Atget photographed the Luxembourg Gardens frequently, and with obvious satisfaction. (See Vol. II, pls. 111–16 and related figures.) Atget filed plate 3 in the Art of Old Paris series, and by strict accounting it might more logically have been included in Volume II, except that the substance of the picture seems to be concerned at least as much with the four men enjoying the indolent pleasures of a modern park as with the seventeenth-century palace of Marie de Médicis.

This is an advanced picture for the Atget of 1899. The inversion of the normal hierarchical status of the subject's several elements, the relatively complex lighting scheme, and the open asymmetry of the design would suggest a somewhat later date. It is perhaps also the first time in Atget's work in which the empty park chair seems to assume the role of a character in the story. (See Vol. II, pls. 107, 108, 112, 115, and fig. 82.) By the 1930s, after the park chairs of Kertész and Brassaï, the theme had become a standard riff for photographers of Paris. Its moment of glory is memorialized by Henry Miller's hilarious apotheosis of Brassaï's *Chair*: "It is a chair of the lowest denomination, a chair which has been sat on by beggars and by royalty, by little trot-about whores and by queenly opera divas. It is a chair which the municipality rents daily to any and every one who wishes to pay fifty centimes for sitting down in the open air. . . . THIS IS A CHAIR. Nothing more. No sentimentalism about the lovely backsides which once graced it, no romanticism about the lunatics who fabricated it, no statistics about the hours of sweat and anguish that went into the creation of it, no sarcasm about the era which produced it, no odious comparisons with chairs of other days. . . . Perhaps the Prince of Wales

Fig. 4

Fig. 5

Fig. 6

once sat on it, perhaps a holy man, perhaps a leper, perhaps a murderer or an idiot. *Who* sat on it did not interest Brassaï in the least. It was a spring day and the foliage was greening; the earth was in a ferment, the roots convulsed with sap." (*Max and the White Phagocytes*, The Obelisk Press, 1938.)

Pl. 4. *Café, avenue de la Grande Armée.* (1924–25.) PP:45.
MoMA 1.69.3551
Fig. 2. *Untitled.* (1899–1900.) PP:3259. MoMA 1.69.983
Fig. 3. Paul Géniaux. *Un Café à Suresnes.* 1900–10.
Musée Carnavalet, Paris

Typically, Atget's early picture of the outdoor café (fig. 2) shows the place in active use. One might say that he gives us the scene enveloped in the haze of the half-seen, ephemeral moment; or one might say that the picture is not really resolved —that for all its vivacity only parts of it are working.

The crepuscular morning light that lends such beauty to the café of plate 4 is of course as ephemeral and as unrepeatable as a human gesture, although the pace at which it disappears is a little slower. The subject matter of the picture is evanescent, but the picture is fixed in equipoise.

By the turn of the century Atget had abandoned the attempt to deal with the quicker kinds of flux, leaving that rich vein to his contemporaries (see fig. 3) and to those who would follow.

Pl. 5. *Le Dôme, boulevard Montparnasse.* Juin 1925. AP:6597.
MoMA Study Collection 84.37. Print by CAW, 1984.
Same as MoMA 1.69.3896

Perhaps as a courtesy to the sidewalk sweeper, the front row of chairs is turned sideways at this early hour, but when in use their proper orientation is toward the boulevard. Walker Evans considered it a proof of the superiority of French culture that one could sit on a café terrace and without dissembling or embarrassment closely study one's fellow man.

Pl. 6. *Coin, boulevard de la Madeleine, 8ᵉ.* Juin 1925. AP:6587.
MoMA 1.69.1310

The subjects in this volume demonstrate again Atget's aversion, late in his life, to photographing deep space with the sun behind him. Foggy weather, or a low sun in his face, shining through the palpable Paris atmosphere, gave him a smooth and continuous aerial perspective, and placed each part of his subject in its proper plane in the spatial recession.

Atget's title tells us that the picture was made in a part of the city that was (and is) rich in tourists; even so, the preponderance of English-language magazines is surprising.

Pl. 7. *Place Dancourt, Théâtre de Montmartre.* Juin 1925. AP:6603.
MoMA Study Collection 84.38. Print by CAW, 1984

Pl. 8. *Boulevard de Bonne-Nouvelle.* Mai 1926. AP:6678. MoMA
Study Collection 84.39. Print by CAW, 1984. Same as
MoMA 1.69.1708
Pl. 9. *Boulevard de Bonne-Nouvelle.* (1926.) AP:6679. MoMA
Study Collection 84.40. Print by CAW, 1984. Same as
MoMA 1.69.1707
Fig. 4. *Boulevard de Bonne-Nouvelle.* 1926. AP:6680. MoMA
1.69.3699
Fig. 5. *Boulevard Saint-Martin.* (1926.) AP:6684. MoMA 1.69.1706

Throughout his life Atget withheld recognition from the Eiffel Tower and the Arc de Triomphe. and for most of it he maintained an almost equal reserve toward the automobile. Except for a few perfunctory record shots of autobuses for his *voiture* series, the motorcar seems to play no important role in Atget's work until 1922, when he made the superb portrait of the Renault touring car, as handsome and strange as a heathen conqueror, in the homely, decaying courtyard (pl. 76). Perhaps the beauty of this picture persuaded Atget that automobiles were, after all, merely a variant of the carriage, for during his last

Fig. 7 Fig. 8 Fig. 9

years they appear with some frequency as important presences in his Paris street scenes.

It is likely that plates 8 and 9 and figure 4 were made on the same day, and virtually certain (on the evidence of Atget's note-books) that figure 5 was made a day or two (or a few days) later. It is interesting that Atget returned with such alacrity to the scheme of plate 8, and that he succeeded in making, on a different site, a picture so closely related, both in subject matter and design, to the prototype.

It is tempting to speculate that Atget may have recognized that cars tended to stop in predictable places, perhaps at inter-sections or pedestrian crossings, and that if he stationed his camera accordingly he could include cars in the streets of his compositions, in spite of his long exposures. If so, the strategy worked imperfectly in figure 5, in which the gray car and the black one were in life the same, which stopped once, edged forward, and stopped again for a longer stay. Atget's album indicates that the picture was made at 8:30 in the morning, and on a gray morning in May the kind of plate he used evidently required an exposure counted in seconds.

Pl. 10. *Boutique journaux, rue de Sèvres.* (1910–11.) PP:225. MoMA 1.69.1521

Pl. 11. *Pompes funèbres.* (1910.) ve:19. MoMA Study Collection 84.41. Print by CAW, 1984

Pl. 12. *Bitumiers.* (1899–1900.) PP: 3231. MoMA 140.50
Pl. 13. *Bitumiers.* (1899–1900.) PP:3228. MoMA 1.69.982
Fig. 6. *Bitumiers.* (1899–1900.) ve:69, formerly PP:3233. MoMA 1.69.963

Plates 12 and 13 are among the most remarkable successes of Atget's early impressionist style. Beyond their atmospheric glow and graphic beauty, they touch the abstract ideal of noble and elegant labor. Perhaps Atget abandoned this style because it

was too abstract—not sufficiently specific—for his needs. If one needed a description of the workers or their tools, these photographs would not help.

During the days when Atget made these pictures, he made at least five others of the *bitumiers* at work. A decade later he selected three of them for inclusion in his first album of *petits métiers*, choosing the pictures reproduced here as plates 12 and 13 and figure 6. The last is in comparison a lumpen, confused, and graceless picture, but we are nevertheless grateful for the information that it gives us about the wooden buckets, and the workings of the demonic machine, and the men, one of whom we might recognize on the street.

Pl. 14. *Paveurs.* (1899–1900.) PP:3221. MoMA 1.69.902
Fig. 7. *Paveurs.* (c. 1898.) PP:3008. MoMA 1.69.973

Atget's celebrated series on the street tradesmen of Paris was begun early in his career, and finished quickly. Although a few pictures that would fit within the *petits métiers* rubric may have been made in 1898, the main body of the series was done in 1899 or 1900. It is difficult to establish the precise boundaries of the series; perhaps Atget himself did not conceive of it as a distinct subject until this possibility was proposed by some of the pictures that he had already made in his early, intuitive re-portage of Paris street life. The intent of plate 14—a picture of a role and the individual who serves it—is clearly different from that of the genre scene that Atget made sometime earlier from similar materials (fig. 7). Nevertheless, the earlier picture might have carried the germ of the later.

In 1910 or soon afterward, Atget constituted a paper album entitled *Album N° 1, Paris Pittoresque, Petits Métiers*, which contained approximately fifty-five pictures selected from his first, wide-ranging, Picturesque Paris series. The selection includes most of the trades that Atget photographed, and the most suc-cessful pictures; it might be regarded as Atget's own definition of the essence of a project that was, in the making, much larger

Fig. 10 *Fig. 11* *Fig. 12*

and much less precisely defined. It seems unlikely that an Album Nº 2 was ever begun.

Pl. 15. *Commissionnaire.* (1899–1900.) PP:3216. MoMA 1.69.899
Fig. 8. *Les p'tits métiers de Paris: commissionnaire.* n.d. Postcard, Atget Archives, MoMA

A *commissionnaire* was a person available for the delivery of messages or the moving of such furniture or other objects that he could carry on his back, with the aid of the pack frame that stands beside him. The newspaper he is reading was the most popular in the world. The *Petit Journal*, a republican paper, claimed a circulation of 1.1 million in 1904.

About 1905 the publisher Victor Porcher produced a series of eighty postcards of Atget's photographs, under the title "Les p'tits métiers de Paris." The title is interpreted very loosely, and the series includes many subjects that Atget would have cataloged in other corners of his system. The pictures reproduced in the postcard series seem not to be represented among the negatives that survive at The Museum of Modern Art. Perhaps the publisher bought negatives as well as prints, to assure the exclusivity of his rights. This might explain why Atget gave him only his second-best work.

Pl. 16. *Marchand de paniers.* (1899–1900.) PP:3209. MoMA 1.69.1003
Fig. 9. Reproduction of a drawing by Gavarni. n.d. CO:56. MoMA Study Collection print, 1978

The pictorial depiction of street trades and other emblematic roles and character types was an ancient tradition by Atget's time. During the nineteenth century in France that tradition was continued and renewed by artists such as Gavarni, Théophile Steinlen, Jean-François Raffaëlli, and of course Daumier. It seems doubtful that Atget began his *petits métiers* series as a conscious contribution to that tradition; the tentative, gradual evolution of this series out of its beginnings in candid street reportage suggests that Atget began without a clear model. It is possible, however, that Atget recognized, in the process of defining the style and content of this segment of his work, an

affinity with the older (and continuing) tradition. It is certain that Atget was not completely unfamiliar with the art of Gavarni. The work reproduced as figure 9 is from a photographic copy made by Atget. It is one of a pair that Atget copied; the other depicts a stereotypical middle-class character and bears the caption *Ne lui parlez pas des artistes!* Unfortunately the negatives are, at this time, undatable.

Pl. 17. *Marchand de paniers de fil de fer.* (1899–1900.) PP:3243. MoMA Study Collection 84.42. Print by CAW, 1978. Same as MoMA 1.69.904

The lighting in the *petits métiers* pictures is generally straightforward, functional, and unnoticeable. It was perhaps fortuitous that Atget photographed this man in a severely raking sidelight that renders so beautifully his wire baskets and the cloud of pipe smoke that obscures his face. If so, Atget presumably learned from his good fortune, although it is several years before he seems consistently alert to the plastic and expressive possibilities of light.

Pl. 18. *Marchand abat-jours.* (1899–1900.) PP:3196. MoMA 1.69.892
Fig. 10. *Untitled [candy vendor].* (1899–1900.) PP:3248. MoMA 150.50
Fig. 11. *Untitled [place Saint-Médard].* (1899–1900.) PP:3241. MoMA 1.69.4330
Fig. 12. *Petit marché, coin rue Mouffetard.* (1910.) PP:209. MoMA Study Collection print, 1978
Fig. 13. *Untitled [place Saint-Médard].* (1926–27.) PP:154. MoMA Study Collection print, 1978
Fig. 14. *Marchand au panier.* (1899–1900.) PP:3194. MoMA Study Collection. Print by Berenice Abbott, n.d.

Almost without exception, the *petits métiers* pictures are characterized by a very shallow depth of field—a very limited plane of sharp focus, behind and in front of which the subject is rendered progressively indistinct. Plate 18 is a radical exception, and not easy to understand.

The shallow depth of field evident in the other pictures of the

Fig. 13 *Fig. 14*

series is created by using the lens at or near its maximum opening—the condition in which it admits the most light, and permits the shortest exposure time. The chief advantage of this procedure was that the subject, in a good light, need hold the pose no longer than a fraction of a second. (In plate 21 and figures 10 and 7, the moving figures in the background would indicate, at a guess, an exposure no longer than a twenty-fifth of a second.) In plate 18, a picture that otherwise fits neatly within the general conception of the series, Atget has rendered his subject sharp from foreground to the horizon. It is possible that he has done this for pictorial reasons, perhaps because he liked the pattern of the cobblestones, but the puzzle could have a simple technical explanation.

Atget characteristically used a lens of shorter than normal focal length for his camera—a relatively wide-angle lens. It is the inherent nature of lenses that their depth of field increases as their focal length decreases. A five-inch lens, set at the same light-gathering setting as a ten-inch lens, will describe a much deeper segment of its field of view in focus.

It would appear that most of the *petits métiers* series was made with a longer lens than we normally associate with Atget, and that plate 18 was made with an exceptionally short one. In this picture Atget's camera is so close to the subject that the right foot of the lampshade seller is seen almost from above, and the lampshade on the left seems to rush off into a remote middle distance. Camille Recht, in his introduction to the German edition of the 1930 Jonquières book, suggests that the lampshade seller looks like a murderer of young girls, but perhaps it was only the unfamiliar drawing of the wide-angle lens.

We think of Atget as a photographer who reduced the technical aspects of his craft to an absolute minimum. Man Ray said (*Image*, Apr. 4, 1956) that he used a simple rectilinear lens with no shutter; Berenice Abbott has sometimes said that it was a rectilinear of normal focal length (*Complete Photographer*, no. 6, 1941) and sometimes that it was a *trousse* (convertible lens) that allowed a variety of focal lengths (*The World of Atget*). Peter Galassi pointed out to me that figure 11 was clearly made with a very long focal-length lens. Two later pictures of the market

of Saint-Médard (figs. 12 and 13) were made from a vantage point very close to that of the earliest picture; the 1910 picture was made with a rather short lens, and the last one with a lens of normal focal length. It is clear that the question of Atget's lenses deserves closer study.

On at least the three occasions illustrated above, Atget attempted a general view of the market, something perhaps in the spirit of Thomas Shotter Boys, but more immediate and real. His final attempt (fig. 13) was one of his last pictures. It is, nevertheless, not a success.

The market of the Rue Mouffetard was an easy walk from Atget's flat, and he enjoyed many successes there, including the picture of the conversation between the beautiful young woman and the *marchand au panier* (fig. 14). John Fraser said of it: "The two figures stand relaxedly, self-confidently, she a little taller than him but perfectly poised and very feminine, he very masculine, the two of them meeting as individuals and equals." (*Cambridge Quarterly*, Summer 1968, p. 224.)

Pl. 19. *Rémouleur.* (1899–1900.) PP:364, formerly PP:3211. MoMA 1.69.895

Pl. 20. *Porteuse de pain.* (1899–1900.) PP:3214. MoMA 1.69.1939
Pl. 21. *Mitron.* (1899–1900.) PP:3213. MoMA 1.69.897

The *mitron* and the *porteuse* evidently work for the same baker. They are photographed in the same spot, and surely on the same midday. The basket on the head of the *mitron* is surely the same one that rests on top of the cart of the *porteuse*.

Pl. 22. *Untitled [window washer].* (1899–1900.) PP:3277. MoMA 1.69.909
Pl. 23. *Untitled [ragpicker].* (1899–1900.) PP:363, formerly PP:3276. MoMA 1.69.889
Fig. 15. *Marchand papier.* (1899–1900.) PP:3279. MoMA 1.69.908
Fig. 16. *Marchand de fleurs.* (1899–1900.) PP:3278. MoMA 1.69.4161

By the time the *petits métiers* series drew to a close, Atget knew exactly what he wanted these pictures to be, and went about

Fig. 15 *Fig. 16* *Fig. 17*

making them in the most direct and economical way. The four pictures listed above are the last, save two, in the series. They were made in the same place and (with the conceivable exception of plate 23) on the same day. The stain on the sidewalk was presumably the work of the window washer.

As finally defined, the crux of this series was a matter of costume, tools, and stance. The subjects are drawn as self-sufficient and isolated facts; almost every one of them could be cut from its ground to create a free-standing paper doll. The solution is appropriate to the emblematic function of the pictures, which concentrates on the role rather than the individual and is unconcerned with context.

Pl. 24. *Tombereau.* (1910.) ve:11. MoMA 1.69.2627

The *tombereau* was a dump cart; it allowed the discharge of its load without raising the cart's tongues, and thus without requiring the unharnessing of the horse. The *tombereau* does not have brakes, so its driver has secured it by placing stones in front of its wheels. In literary and political contexts, the *tombereau* is better remembered as the prescribed vehicle for transporting the condemned to the guillotine at the time of the Revolution.

Pl. 25. *Camion.* (1910.) ve:28. MoMA Study Collection 84.43. Print by CAW, 1984

The *camion* is parked before the office of the *camionneur*, or moving man. The great wicker hampers are reusable packing cases. Unlike the *tombereau*, the *camion* has brakes (on the rear wheels), but they are perhaps not foolproof, so the driver has used stones as a backup, or redundancy, measure.

Pl. 26. *Laitière.* (1910.) ve:23. MoMA Study Collection print, 1978

Pl. 27. *Voiture.* (1910.) ve:37. MoMA Study Collection 84.45. Print by CAW, 1984. Same as MoMA 1.69.920

Pl. 28. *Joueur d'orgue.* (1898–99.) PP:360, formerly PP:3124. MoMA Study Collection 84.46. Print by CAW, 1984

The organ player is perhaps the first of the *petits métiers* series in which the subjects stand frankly before the camera, conscious of their role as participants and collaborators in the making of a picture. The extraordinary success of this work may have influenced Atget's approach to the series as a whole, but never again in the following months was his deliberate, almost taxonomic new method so fruitfully contested by the irrepressible vitality of his subject. John Fraser said: "Their clothes are heavy-looking, redolent of dirt and perspiration; the man is not especially prepossessing, the woman is almost a midget; . . . the oilcloth cover on the piano recalls the weathers that they face, and the bourgeois facade behind them is not hospitable. Yet the expression of radiant, exultant happiness and pride on the woman's face is unequaled by anything I can recall in art except the closing shot of Marlene Dietrich in Sternberg's *Scarlet Empress;* and, with the incongruity in ages, yet manifest closeness of the couple, the picture seems to me one of the greatest pictorial images of *love* that we have." (*Cambridge Quarterly*, Summer 1968, p. 223.)

Pl. 29. *Place de la Bastille, bouquiniste.* (1910–11.) PP:226. MoMA 1.69.4220

Pl. 30. *Joueur de guitare.* (1899–1900.) PP:3254. MoMA Study Collection 84.47. Print by CAW, 1984

Fig. 17. *Joueur de guitare.* (1899–1900.) PP:3255. MoMA 1.69.907

Atget often made two exposures of his street-trade subjects. When he did so, the second shot was not a matter of insurance against technical failure, but a clearly different conception, and showed a different fact. In the case of the guitar player Atget included both versions in his edited album of *petits métiers* that he compiled years later. In figure 17 the musician's handsome Burt Reynolds face is lost, but the grace of his stance is elegantly drawn, and the cape on his arm might be a muleta.

Pl. 31. *Boutique clefs, quai de la Rapée.* (1910–11.) PP:227. MoMA 1.69.2401

Throughout his life there was a strong conceptual element in Atget's work. Typically the ideas that fueled his work began as

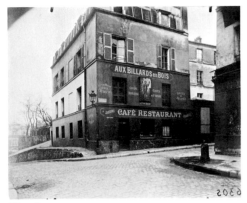

Fig. 18

broad, inclusive interests that were gradually delimited and fo-
cused by the process of work. The earlier, discursive stages of
Atget's explorations, like sketchbooks, proposed many possi-
bilities, some of which were accepted as the basis for more
concentrated investigation.

Around 1910 Atget apparently focused his attention on a few
earlier pictures that touched on the ordinary commercial life of
Paris. As he had done before and would do again, he pulled
these pictures from their former places and made them the be-
ginning of a new subseries that considered the shops and stands
of small tradesmen, a class a step up the economic ladder from
the ambulatory street trades. As his conception took shape,
Atget worked rapidly and with confidence. Plate 60 (*Fritures*)
was the fifth picture to be added to the new series; plates 10, 29,
31, and 32 were done within a span of five negatives for this
series.

Pl. 32. *Boutique, square du Bon Marché, rue de Sèvres.* (1910–11.)
PP:223. MoMA Study Collection 84.48. Print by CAW,
1984. Same as MoMA 1.69.2312

Pl. 33. *Rue St-Vincent, Montmartre.* Juin 1922. AP:6369, MoMA
1.69.1989

Fig. 18. *Montmartre, cabaret, rue St-Rustique.* Mars 1922.
AP:6305. MoMA 1.69.2918

According to the street sign (fig. 18), the café stands not on the
Rue St-Vincent, but two blocks away on the Rue St-Rustique.
Sacré Coeur is within a stone's throw.

Plate 33 was not made on the same occasion as figure 18, but
three months later, after Atget had had ample time to consider
his first handsome and well-made picture. His second try epito-
mizes the certain intuition for perfect and surprising pictorial
structure that lies at the heart of Atget's greatest late work. His
framing of the facade is logically inexplicable and visually per-
fect. Like plates 34 and 57 (and pl. 69, Vol. II), this picture
represents a family of discoveries that gave Atget pleasure dur-
ing the first half of the twenties: a facade slightly canted away
from the picture plane, its component parts disposed within the
frame according to the dictates of a secret geometry.

It would seem that Atget is working here from a vantage
point somewhat higher than the sidewalk, an unusual procedure
for him.

Pl. 34. *Boulevard de la Chapelle, 18ᵉ.* (1921.) PP:21. MoMA
Study Collection 84.49. Print by CAW, 1984. Same as
MoMA 1.69.2148

Pl. 35. *La rue de Nevers.* Mars 1924. AP:6464. MoMA 1.69.1857

The area seen in plate 35 is also visible in a picture Atget made
two years later, from a vantage point ninety degrees clockwise
(see pl. 92, Vol. II). Demolition is in progress in plate 35; in the
1926 picture, the closest building on the left has also been razed.
One of the functions of a substantial body of photographs made
in one place over an extended period is to produce a record of
changes that are so pervasive, gradual, and ordinary that their
effect over time is, to our daily consciousness, invisible. By
showing us the recent past, photographs vivify the present.

Pl. 36. *Boutique, 93 rue Broca.* (1912.) PP:390. MoMA 1.69.2138

Pl. 37. *Vieille boutique, rue des Lyonnais 10.* (1914.) PP:494.
MoMA 1.69.2128

In contrast to the reserve of plates 33 and 34, these earlier
pictures of commercial facades are full of the stuff of Dickensian
anecdote, of wonderful details bearing on the trade of shoe-
making and the lives of specific shoemakers, that we can read as
a story, or study as evidence, or wonder about: use as the cata-
lyst for fruitless but luxurious woolgathering. Was the aristocrat
in the window of 10 Rue des Lyonnais exiled by the Czar? For
what offense, real or contrived? What is his relation to the eye-
rolling, teenage slattern lurking in the doorway to the flat
above, which had clearly known better days, etc., etc.?

Perhaps pictures that we give our attention to give themselves
to us and become accomplices in our vices and spokesmen for
our prejudices. But it is an artist's function to reject this view,
and to make things that lend themselves less willingly to our
hunger for corroboration but are in their own terms true, even
if mute. Atget had never courted charm, but his work after the

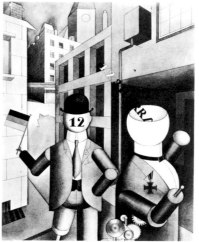

Fig. 19

Fig. 20

Fig. 21

Fig. 22

Fig. 23

war became progressively lean and serious, more concerned with the principled structures that might be wrought with a camera.

Pl. 38. *Boutique aux Halles.* (1925.) PP:93. MoMA 1.69.1948
Pl. 39. *Boutique aux Halles.* (1925.) PP:92. MoMA 1.69.2449
Fig. 19. George Grosz. *Republican Automatons.* 1920.
 Watercolor. MoMA 120.46, Advisory Committee Fund
Fig. 20. Giorgio de Chirico. *The Mathematicians.* 1917. Pencil
 drawing. MoMA 24.35, gift of Mrs. Stanley Resor

Man Ray said that when he approached Atget about reproducing some of his pictures in *La Révolution surréaliste*, the aging photographer requested that his name not be credited. If accurate, the remark is open to a dozen interpretations, but none of them would suggest that Atget was eager to be associated with the Surrealist idea. The alleged conversation presumably took place in 1926, when four of Atget's photographs were used in Breton's magazine. The photographs reproduced here as plates 38 and 39 were made in the previous year. The degree to which Atget was aware of the achievements and philosophical positions of the various camps of high modernism is unknown, but considering the size and variety of his clientele it seems unlikely

that he could have been totally ignorant of the various artistic revolutions that had gone on around him during his lifetime. It is possible, however, that he did not focus on what he peripherally knew, that it was not essential to him, and that what was surreal in his work came not from Surrealism, but from a source common to both, a new sensibility that recognized an affinity between men and long phyla of lower creatures and insensate tools.

After a million subsequent photographs of dummies in store windows, Atget's photographs of the Boutique aux Halles remain unsettling. The *presence*, the confident superiority with which these changelings review us is, we can hope, an illusion, a trick of legerdemain, a matter of vantage point.

Pl. 40. *Avenue des Gobelins.* (1927.) PP:157. MoMA 1.69.1545
Pl. 41. *Avenue des Gobelins.* (1927.) PP:159. MoMA 1.69.1509
Fig. 21. *Avenue des Gobelins.* (1926.) PP:121. MoMA 1.69.2450
Fig. 22. *Avenue des Gobelins.* (1927.) PP:156. MoMA 1.69.2432
Fig. 23. *Avenue des Gobelins.* (1927.) PP:158. MoMA 1.69.2458
N.B.: The dating of plates 40 and 41 is more precise here than
 in the captions that accompany the plates. Further study of
 Atget's notebooks has convinced the authors that numbers

Fig. 24

Fig. 25

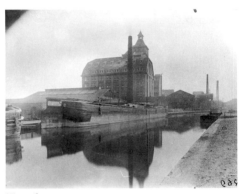
Fig. 26

Fig. 27

larger than 139 from Part 3 of the Picturesque Paris series can be confidently dated as 1927.

Atget first photographed the store of M. Sergent in June of 1926 and made the picture reproduced as figure 21. He returned the next year, in May or later, and made four more pictures, all reproduced here. It appears that he returned more than once; figure 22 seems to show the same entrance as that shown in plate 41, but from the opposite approach. The garments on the mannequins have been changed, except for the one in the foreground of plate 41, which has remained the same. The progression of Atget's vantage point is interesting. In his first picture he maintains a reasonable distance from the dummies, and they remain elements in a street scene; in his second try (fig. 22) he moves closer, but still leaves room for a head to be added to the mannequin in the white suit. In his last three pictures he forgoes the possible future head and concentrates on what is already there. The dummy in plate 40 is scribing a circle with the toe of his shoe, like a small boy caught sinning. Plate 41 is the last photograph that Atget made in the Picturesque Paris series, and perhaps the last in any series.

Pl. 42. *Rue Mouffetard.* (1926.) PP:105. MoMA 1.69.2452

Pl. 43. *Rue Mouffetard.* (1926.) PP:106. MoMA 1.69.2442

Pl. 44. *Impasse Samson, Châtillon.* (1922.) E:7001. MoMA 1.69.3115

Pl. 45. *Saint-Denis, canal.* (1925–27.) LD:1264. MoMA 1.69.3493

Fig. 24. *Saint-Denis, canal. Matinée d'août par temps de pluie.* (1925–27.) LD:1263. MoMA 1.69.3492

Fig. 25. *Bassin de la Villette.* (1925–27.) LD:1268. MoMA 1.69.1417

Fig. 26. *Pantin (Usines-canal).* (1925–27.) LD:1269. MoMA 1.69.3495

Fig. 27. *Coin, quai de la Tournelle.* (1910–11.) PP:244. MoMA 1.69.1902

Sometime after August of 1925 Atget made a sequence of eight consecutive negatives of the industrial area along the Canal de Saint-Denis. After a brief interruption in his Landscape-Documents series, he returned to the motif and made four more negatives. By this point in his life Atget tried to make every negative count, and twelve negatives made within a short period on a single site can be taken as evidence of enthusiasm for its potential. Atget's skill at this juncture can perhaps be com-

Fig. 28

Fig. 29

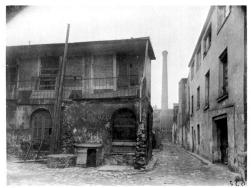

Fig. 30

prehended by comparing his first and second tries with this material. Figure 24, his first attempt, is a clear and well-ordered image that captures something of the angular, dark, spiky beauty of the industrial landscape of the period. For his second attempt (pl. 45) he moves to his left, under the bed of the bridge visible in figure 24, sacrificing the beauties of the bridge and the conveyor that spans it, in order to clarify and articulate the profile of the opposite bank, which now resembles a talented but dangerous insect. The pictures that Atget had already made at the reflecting pools of Saint-Cloud were inevitably in his mind.

Figure 26 plays a different, subtler game; here the parts are not strung out in a line but piled one upon the other, and articulated only by variation in tone.

Atget had appreciated the beauty of industrial forms much earlier (fig. 27) and handled the problem well enough if it came to him as a work of discrete sculpture. To see the broad industrial landscape as sculpture took longer.

Pl. 46. *Cour, 3 ruelle des Reculettes.* (1926.) AP:6622. MoMA Study Collection 84.50. Print by CAW, 1984. Same as MoMA 1.69.2265

Fig. 28. *Cour, 3 ruelle des Reculettes.* Mars 1926. AP:6623. MoMA Study Collection print, 1978

Fig. 29. *Passage Moret, ruelle des Gobelins.* Mars 1926. AP:6629. MoMA 1.69.1489

Fig. 30. *Passage Moret, ruelle des Gobelins.* (1926.) AP:6632. MoMA 1.69.4231

Fig. 31. Paul Strand. *Stone Mill, New England.* 1946. The Paul Strand Foundation

Fig. 32. Maurice Utrillo. *Ruelle des Gobelins.* 1927. Oil on canvas, unlocated; with Balzac Galleries, Paris, 1930

In 1926 Atget's first additions to his Art in Old Paris series were seven negatives made in the old industrial area of the Gobelins, near the Place d'Italie. Plate 46 and figure 28 reproduce two adjacent exposures from this sequence. The central building in figure 28 is also seen on the extreme left edge of plate 46. Several days later Atget returned to the area, this time east of the Avenue des Gobelins, and photographed again old dyeworks and

tanneries, similar to those that he had photographed a quarter-century earlier, a bit to the south in Gentilly. In this sequence of eight pictures near the Passage Moret, Atget seems consistently to take special care with the placement of the smokestacks, and recognizes that their symbolic and graphic force is increased if they are enclosed in a confining space that offers resistance to their thrust. This knowledge was part of a larger lesson concerning the possibilities of photographic design that was learned by advanced photographers early in this century, knowledge, I think, that could be gained directly from the exploration of the medium.

Barbara Michaels has noted that figure 30 served as the model for a 1927 painting by Maurice Utrillo. Utrillo owned an extensive and excellent collection of Atget's prints, most of which were apparently not used as sources for his paintings. Among the pictures reproduced in this volume, Utrillo owned (in addition to fig. 30) plates 10, 21, 28, 46, and 57, and perhaps others.

Pl. 47. *Poterne des Peupliers, zoniers.* (1913.) PP:429. MoMA 1.69.4154

Fig. 33. Charles-Joseph Traviès de Villers. *Liard, chiffonnier-philosophe.* 1834. Lithograph. Stanford University Museum of Art, Museum Purchase Fund

The Poterne des Peupliers (the back door, perhaps, to the Street of Poplars) was an area just across the fortified wall, south of the Place d'Italie. It was part of the Zone, a belt a quarter-kilometer or more deep that lay outside the fortifications proper and on which permanent structures were in theory prohibited, on the basis that they might interfere with the fortifications' ability to defend the city. (It had in fact been demonstrated in 1870 that the fortifications were unable to defend the city, but in spite of continuous efforts to find a solution, substantial parts of the Zone survived World War II much as they had been when Atget photographed them.) The prohibition of permanent structures made the Zone a refuge for ragpickers (*chiffonniers*) and gypsies.

The ragpicker was a culture hero and formidable political symbol of republican values during the nineteenth century. He

Fig. 31 Fig. 32 Fig. 33

was considered to embody the ideal of independence and offer an alternative to materialist bourgeois standards. Liard (fig. 33), a real person, is said to have spoken some Greek and Latin. The image of the ragpicker as philosopher-king, like the image of ordinary kings, has not been well served by photography.

Pl. 48. *La Bièvre, Gentilly.* 1901. E:6007. MoMA 1.69.1113
Pl. 49. *La Bièvre, Gentilly.* 1901. E:6006. MoMA 1.69.1114

These exceptionally handsome early pictures describe an industrial area that was old and declining at the beginning of the century. One's first impression on studying Atget (if one is unfamiliar with the place names of the Ile de France) is that he must have traveled widely to find subject matter of so rich and various a nature. This student has been surprised to find that a large portion of his work outside of Paris was done within a few miles of the city's southern gates. The industrial wasteland of the Bièvre's tanneries lay within an easy hike of Châtillon and Bagneux and other villages that seem in Atget's pictures to have been lifted intact from a pastoral eighteenth century. (See Vol. I.)

Pl. 50. *Bassin de la Villette.* (1914–25.) PP:521. MoMA Study Collection 84.51. Print by CAW, 1984. Same as MoMA 1.69.3547
Fig. 34. *Bassin de la Villette.* (Probably 1914–25.) PP:519. MoMA 1.69.3546

The Bassin de la Villette is a holding harbor on the shortcut that passes between the Marne and the Seine by way of the Canal de l'Ourcq. As one proceeded from the Bassin toward the Seine, one passed between Baron Haussmann's great abattoir (on the left) and the cattle market.

At present it is impossible to date plate 50 with precision, since its number falls near the junction of the second and third parts of Atget's Picturesque Paris series, but the highly eccentric character of the picture, which shows us nothing clearly except the grubby and adventurous mood of a working port, is characteristic of the photographer's late work.

Pl. 51. *Zoniers, Porte de Choisy.* (1913.) PP:407. MoMA 1.69.947

Among the residents of the Zone were the gypsies, or *romanichels*, also called by the French *égyptiens* and *bohémiens*, the first term being the source of the abbreviated *gypsy*. European gypsies referred to themselves as Rom. The women in the foreground are making little bouquets of lilies of the valley, *muguet*, the traditional nosegay for the first of May. The sign at the rear of the farther wagon advertises their wares, perhaps indicating that Parisians from within the walls came to the Zone to shop.

Pl. 52. *Porte d'Asnières, Cité Trébert.* (1913.) PP:436. MoMA Study Collection 84.52. Print by CAW, 1984. Same as MoMA 1.69.2522
Fig. 35. *Boulevard Masséna.* (1910.) PP:344, formerly z:112. MoMA 1.69.938

Atget made a considerable number of pictures in the Zone that could be characterized as extraordinarily chaotic, messy beyond the requirements of the subject matter, and it is only occasionally that these pictures manage to achieve a sense of principle, to find, one might say, a clarified essence of chaos. In this regard plate 52 and figure 35 seem to this viewer among the more successful of the species; in them the quality of discord and derangement has a certain interior logic.

Pl. 53. *Romanichels, groupe.* (1912.) PP:351. MoMA 1.69.925
Fig. 36. *Untitled.* (1913.) PP:462. MoMA 1.69.927

Atget attempted a number of family groups within his coverage of the Zone; plate 53 is perhaps the most successful of these, and is one of the few pictures in Atget's oeuvre that seem to be true portraits. The young woman in the white blouse is representing not a trade, condition, or group, but herself. Most of Atget's other pictures in this category were more or less compromised by an excess of squirming babies, exuberant dogs, and aging drinkers, and perhaps also by the fact that in the Zone he seems seldom to have made a second exposure, or to have revisited the same subject on a later day. His technique in the Zone also seems a little approximate, his exposures a little short even when there are no squirming babies, as though he feels not wholly at ease.

167

Fig. 34

Fig. 35

Fig. 36

Pl. 54. *Villa d'un chiffonnier.* (1912.) PP:347. MoMA Study
Collection 84.53. Print by CAW, 1984. Same as MoMA
1.69.991

Fig. 37. *Porte de Montreuil.* (1913.) PP:440. MoMA 1.69.939

Atget's titles are factual (even when wrong) and straightforward, and there is no reason, no known precedent, for thinking that his use of the word *villa*, here and in plates 55 and 56, has any ironic intent, even though the choice of word seems a little willful. Perhaps these *chiffonniers* did have a room in the city, and retired to the Zone on weekends.

The rich miscellany of totems, ornaments, or charms that cover the facade and bestride the pediment of the villa seem a mixture of the contrived and the natural. The pheasant (at one o'clock above the door) is surely real, and the dog and lamb, or whatever, on the roof seem to have about them some vestigial resemblance to creatures that once lived. The cat, wired in place in figure 37, was certainly once a living cat. The large birds, dogs, and cats might serve to keep rats at bay; the kewpie dolls and miniature toy horses may have served a more spiritual function.

Pl. 55. *Porte d'Ivry, villa des chiffonniers.* (1910.) PP:340,
formerly Z:104. MoMA 1.69.2528

It is perhaps useless to speculate as to why this photograph is so satisfactory and so moving. It seems a picture that anyone, everyone, would have made exactly like this, at this distance and orientation and at this time of the day and year; it seems a subject that anyone would have recognized for its perfection and importance, and photographed just like this, with perfect clarity and philosophical disinterest; it seems scarcely a picture, but rather a house, in which we think we might like to live.

Pl. 56. *Villa d'un chiffonnier, boulevard Masséna.* (1910.)
PP:342, formerly Z:109. MoMA 1.69.937

Pl. 57. *Boulevard de la Villette 122.* (1924–25.) PP:48. MoMA
1.69.2159

The People's Barbershop is perhaps not closed permanently, in spite of the fact that the standard above the door bears no sign, but only for the night; by the mid-twenties Atget was in the habit of rising early for the best light, and perhaps for peace while working. On this day he got at least the best light. The shop's front has been covered, in amateur fashion, with a material that looks very much like plywood, which in this light glows like sable.

Pl. 58. *Boutique, 2 rue de la Corderie (Temple).* (1910–11.)
PP:240. MoMA 1.69.2282

Pl. 59. *Boutique, Marché aux Halles.* Juin 1925. PP:91. MoMA
Study Collection 84.54. Print by CAW, 1984

Fig. 38. *Au Coq Hardi.* (June 1925.) PP:89. MoMA Study
Collection print, 1978

Fig. 39. *Au Coq Hardi.* (June 1925.) PP:90. MoMA Study
Collection print, 1978

Plate 58, made about 1910 and thus one of Atget's earlier old-clothes photographs, is clearly a better picture than figure 38, of the officers' supply house, made fifteen years later. Most of the area of the later photograph is empty of either visual or referential interest; the store's windows are dead, and the subtle, pearly light describes but does not enliven the long row of boxes that comprise the picture's chief interest. The picture contains much interesting data, but not enough of the plate is working. On his next try (fig. 39) Atget makes a picture that is more economically constructed, but without dramatic incident. On his next and last try (pl. 59) he produces one of his masterpieces, a picture alive from corner to corner, and filled with biographical data on pink-cheeked cadets and dead veterans.

Pl. 60. *Fritures, 38 rue de la Seine.* (1910.) PP:208. MoMA Study
Collection 84.55. Print by CAW, 1984. Same as MoMA
1.69.1643

Plate 60 is one of the earliest pictures that Atget made for the subseries of *boutiques*, after subdividing his Picturesque Paris series in 1910. The shop of the fried-potato merchant was a difficult technical problem; the scale of brightnesses, from the light

Fig. 37

Fig. 38

Fig. 39

objects in the foreground, receiving the full light of the street, to the depths of the dark interior, was greater than could be accommodated even by the very long scale of Atget's printing-out papers. The opaque darkness of the shop's interior produces an air of stygian melancholy that might have surprised the *friture* merchant.

Pl. 61. *Rue de La Reynie, étameur.* (1912.) PP:380. MoMA 1.69.1522

Fig. 40. *Un coin de la rue de Reynie.* (1912.) T:1383. MoMA 1.69.2274

Atget made the picture reproduced as figure 40 as part of the Topography series that he did for the Bibliothèque Historique de la Ville de Paris. Although not without its intellectual rewards, the project was in effect a kind of visual census of particular neighborhoods, and by the nature of its aims required a consistent and methodical approach to a subject that had been defined in conceptual, not visual, terms. On occasion Atget could satisfy his client and his own more intuitive goals in the same photograph, but more typically it would seem that he valued the topographic assignment as an opportunity for exploration, a kind of note-taking that might point to work of a less programmatic kind to be pursued later. Sometimes, as in plate 61, he did not wait till later, but pounced immediately on a subject discovered in the process of making the systematic record. The positions of the tinker's impedimenta make it clear that the two pictures were made at the same time; figure 40 was filed in sequence within the Topography series, and plate 61 in the Picturesque Paris section of Atget's personal document.

Pl. 62. *Rue Pigalle, à 6 h. du matin en avril 1925.* PP:72. MoMA 1.69.1557

By 1925 the neighborhood of the Place Pigalle had changed greatly since the decades when Courbet and Manet and all those who followed made its cabarets command posts of artistic revolution. After World War I it was merely tawdry, a place for the saddest of tourists. The part of the Rue Pigalle that Atget has photographed here seems less tawdry than blighted, but what other photograph shows sunrise in a bad neighborhood so touchingly? By the mid-twenties Atget was in the habit of rising for the early light, but photographing well across the city at six in the morning was exceptional.

Pl. 63. *Marchand de vin, 15 rue Boyer.* (1910–11.) PP:261. MoMA Study Collection 84.56. Print by CAW, 1984. Same as MoMA 1.69.1378

Pl. 64. *Moulin Rouge.* (1926.) PP:109. MoMA 1.69.464

Fig. 41. *Montmartre, Moulin de la Galette.* (1899–1900.) AP:3707. MoMA 1.69.2910

The Moulin Rouge of plate 64 is half nightclub and half movie house, and the third establishment, at least, to bear its famous name. The original *moulins* had disappeared by the turn of the century as the growing city overran the semirural suburb of Montmartre. The Moulin Rouge of Toulouse-Lautrec burned in 1915. By 1926 La Goulue was gone, but the new Moulin Rouge still had Mistinguette (originally Miss Tinguette).

Pl. 65. *Boutique automobile, avenue de la Grande Armée.* (1924–25.) PP:44. MoMA Study Collection 84.57. Print by CAW, 1984. Same as MoMA 1.69.1542

By the time he made this picture Atget had made a hundred photographs of shop windows, and there were always reflections in the glass. Atget's own image appears there frequently enough to make us wonder whether even this extraordinarily self-effacing artist was amused to see his visual signature as part of the content of the work. But in the mid-twenties the reflections assume a new authority; they become not a peripheral problem to be minimized but an important part of Atget's subject. (See pl. 59 and pls. 94 through 102.) *Boutique automobile* is one of the first of Atget's pictures in which the window reflections become so active and essential a part of the design and content of the image. It might be pointed out that the balance between the glass as window and the glass as mirror shifts as the negative is printed lighter or darker.

Fig. 40 Fig. 41 Fig. 42

Pl. 66. *Cabaret de L'Enfer, boulevard de Clichy 53.* (1910–11.)
PP:202. MoMA 1.69.2147

Fig. 42. *Cabaret de L'Enfer, boulevard de Clichy 53* (*18ᵉ arr*).
(1900.) PP:201, formerly AP:4085. MoMA 1.69.2183

Fig. 43. *Cabaret de L'Enfer.* (1910–11.) PP:201. MoMA 1.69.2424

Atget changed numbers 4085 and 4087 to 201 and 202 in 1910; it appears that when he photographed the building again the following year he retired the earlier plates and used their numbers for the new negatives. This is the only case of which I am aware where Atget reused an old number for a subsequent picture of the same subject. He apparently regarded the new picture as a replacement, not an addition; thus it was not his intention to document the spread of the funguslike growth across the building's facade.

Pl. 67. *Versailles, maison close, Petite Place.* Mars 1921. PP:11.
MoMA 1.69.930

Fig. 44. Eugène Guérard. *Les lionnes, nᵒ 2. Le soir.* 1845.
Lithograph. Courtesy Bibliothèque Nationale

Early in March of 1921 Atget made what was perhaps his first, and arguably the best, of his prostitute pictures (pl. 74), and filed it in his Art in Old Paris series where it was surrounded by architectural subjects. About the same time he photographed a brothel in the town of Versailles (pl. 75), and filed it in his Landscape-Documents series. It is possible that these assignments, on reflection, seemed almost as arbitrary to Atget as they do to us; before March was finished he had once again revived his Picturesque Paris title, and began its third incarnation with a brief series of prostitutes and brothels. It is also possible that plates 74 and 75 were seen by the painter André Dignimont, an enthusiastic collector of sexual *documenta*, and that they inspired Dignimont to commission Atget to pursue the subject. Whatever the history of the commission, it did not amount to much in quantitative terms; after a dozen negatives the project seems to have been abandoned. Perhaps the prostitutes that Atget photographed failed, in one way or another, to meet Dignimont's standards. Atget's pictures certainly fail to achieve even

a suggestion of the marvelous lubricity mastered by earlier specialists such as Guérard, a favorite of Baudelaire.

Pl. 68. *Rue Asselin.* (1924–25.) PP:47. MoMA 1.69.998

Rue Asselin here is presumably the same street as Rue Asselin in plate 74, and therefore not to be confused with the Rue Asseline, which is not in La Villette (Atget's first neighborhood on settling in Paris) but in the Fourteenth Arrondissement, just across the Montparnasse Cemetery from the flat where Atget lived after the turn of the century. Rue Asselin of La Villette is not to be found on postwar maps; it is now called Rue Turot, and can be found just a block south of the Place du Colonel Fabien, which was called in Atget's time, perhaps more appropriately, the Place du Combat.

Pl. 69. *14 rue Mazet.* (1925.) PP:87. MoMA Study Collection
84.58. Print by CAW, 1984

Fig. 45. *Femme.* (1925–26.) PP:62. International Museum of
Photography at George Eastman House; formerly
Man Ray Collection

In 1560 the City of Paris issued an ordinance prohibiting brothels; after a little thought the law was revised to require in addition that all prostitutes leave the city within twenty-four hours. Presumably the law was repealed at some later date. The regulation of prostitution in France during Atget's time was based on no clearly visible law at all, but came under the discretionary authority of the prefect of police. Although legally odious, the system apparently worked reasonably well in terms of the goal of public hygiene; the proportion of French soldiers hospitalized for venereal disease during the period of 1890–92 was lower than that of Austria, Italy, England, and the United States, and substantially higher only than that of Germany (Encyclopaedia Britannica, 11th ed.). Some of Atget's clients may have thought that photographs might help illuminate such social and political problems, but it seems likely that Atget was more interested in the eccentric division of this facade, with the distance between

Fig. 43 Fig. 44 Fig. 45

the nodes of the wavelike mountains varied according to the width of the windows.

After his brief concentration on prostitutes and brothels in the spring of 1921, Atget seems to have almost abandoned the subject, although in 1925 he did at least three nudes, including one male, which were probably made in a brothel (fig. 45).

Pl. 70. *Versailles, maison close, Petite Place.* Mars 1921. PP:10. MoMA 1.69.2

Pl. 71. *La Villette, fille publique faisant le quart, 19e.* Avril 1921. PP:12. MoMA 1.69.1938

Plate 71 and plate 74, along with plate 18, seem to represent the extreme case of Atget's fondness for short focal-length lenses. (See note to pl. 18.) In plate 71, the elongation and the closeness of the woman's right leg, and the speed with which the rest of her and the street itself fall away from the viewer, seem to produce a perfect graphic expression of both her superficial availability and her profound remoteness.

Pl. 72. *Coin, boulevard de la Chapelle et rue Fleury 76, 18e.* Juin 1921. PP:20. MoMA 1.69.1475

This appears to be the last of the prostitute pictures that Atget did in the spring of 1921, and perhaps the last that he did on the Dignimont commission. It would be difficult to argue with Dignimont if he had decided that Atget was simply not getting the idea. Dignimont had perhaps invested too much in the idea of sex as magic and mystery to be satisfied with photographs that presented prostitution as just another *petit métier*.

Pl. 73. *Versailles, femme et soldat, maison close.* Mai 1921. PP:17. MoMA Study Collection 84.59. Print by CAW, 1984

Whether for technical reasons or because of some delicacy of feeling, Atget did not photograph prostitutes (as opposed to knife sharpeners, ragpickers, etc.) actually at work, either real or feigned. As a result this tiny segment of his work includes several pictures that are among the score or so in his entire oeuvre that approach the condition of true portraits. In plate 73

the soldier—handsome, friendly, confident, and beyond help—and the woman, with her huge hands, flaccid, dangling arms, and half-successful smile, present themselves to us not as representatives of social categories, but as distant relations, more clearly drawn versions of figures recalled from the yellowing snapshots of ancient family albums.

Pl. 74. *La Villette, rue Asselin, fille publique faisant le quart devant sa porte, 19e.* 7 mars 1921. AP:6218. MoMA Study Collection 84.60. Print by CAW, 1984

In the paper notebook in which this print was filed, Atget added the notation: "robe ocre rouge—chevelure blonde." It is conceivable that Atget was experimenting with a new orthochromatic plate, sensitive to all colors of the spectrum except red, and was curious as to how it would render a brick-colored dress and blond hair. It seems even less likely that he was making color notes for a potential painter client. Perhaps he thought he might try a painted version himself, but it seems unlikely that he would have improved on what he had already made.

Pl. 75. *Maison à Versailles.* (1921.) LD:1017. MoMA 1.69.1265

Long after the abandonment of the ordinance of 1560, which had prohibited brothels, a compromise measure was adopted which allowed brothels but prohibited signs that identified their location. Brothels in Atget's time were allowed no identifying mark other than their properly assigned street number, which rule resulted in their identification by street numbers of extraordinary size. (See also pl. 70.)

Pl. 76. *Cour, 7 rue de Valence.* Juin 1922. AP:6379. MoMA 1.69.1963.

See note for plates 8 and 9.

Pl. 77. *Boulevard Saint-Denis.* Mai 1926. AP:6692. MoMA 1.69.1701

Pl. 78. *Rue des Saules, Auberge du Lapin Agile.* Avril 1926. AP:6675. MoMA 1.69.2893

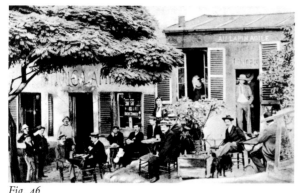

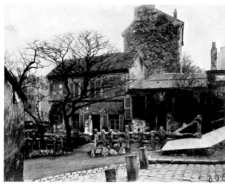

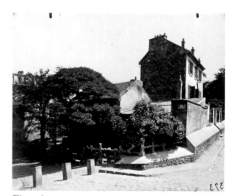

Fig. 46 Fig. 47 Fig. 48

Fig. 46. Photographer unknown. *Le Cabaret du Lapin Agile.* n.d. (after 1904)

Fig. 47. *Lapin Agile.* (1922.) AP:6308. MoMA Study Collection 84.76

Fig. 48. *Montmartre, cabaret du Lapin Agile.* Juin 1922. AP:6373. MoMA 1.69.2882

Fig. 49. *Coin, rue des Saules et Saint-Vincent, cabaret du Lapin Agile, 18ᵉ.* (1925.) AP:6568. MoMA 1.69.2894

The place that in plate 78 seems a tranquil inn in the countryside was one of the most famous and frenetic of cabarets in the annals of modern painting. The fact that Atget photographed it on at least three occasions might be thought to indicate some interest in its history, but he consistently managed to avoid those hours at which even a single painter's presence might compromise his own sense of the peacefulness of the place. Atget's characterization of the place as an *auberge* seems a little wishful; its earlier name had been the Cabaret des Assassins. Atget first photographed it in March of 1922, and returned in June of the same year. With the trees in leaf and with the deep shadows cast by the direct sunlight, his previous vantage point was no longer useful, but by moving to his right he could now describe the sculptural character of the building cluster. Three years later, in April or May, Atget returned to make the radically simplified picture seen in figure 49, recapitulating once again the movement toward visual compactness and economy of reference that identifies his late and greatest work. One would have thought that the Lapin Agile could be considered finished, but Atget returned once more a year later and found an even more welcoming and harmonious *auberge*.

Pl. 79. *Rosier grimpant.* (1910 or earlier.) LD:654. MoMA 1.69.810

Atget has named his picture for the climbing roses, rather than the structure on which they climb, which appears to be a latrine.

Pl. 80. *Intérieur de Mʳ A., industriel, rue Lepic.* (1910.) i:769. MoMA 1.69.3183

In 1910 Atget made a series of photographs of domestic inte-

riors, which he sold later in the same year in album form to the Musée Carnavalet and the Bibliothèque Nationale under the title *Intérieurs Parisiens; Début du XXᵉ Siècle; Artistique, Pittoresque et Bourgeois.*

Atget's captions for these albums are rich in evasions and deceptions. Although in the rest of his work Atget was occasionally imprecise or mistaken in his captions, no other portion of his oeuvre has been discovered in which he took so cavalier an attitude toward accurate labeling.

The captions of the album sold to the Musée Carnavalet indicate that the sixty photographs included represent rooms in the homes of thirteen residents, but in fact they were made in somewhat fewer places. Eight of the pictures were made in the flat of Cécile Sorel, a celebrated actress of the Comédie Française, and were so identified. The remaining fifty-two pictures were identified by an anonymous initial, an occupation, and the street on which the resident lived. At least six of these were made in Atget's own apartment, five of which are identified as the place of an *artiste dramatique*, which is true if misleading, who lived on the Rue Vavin, which is false. The sixth is identified as the room of a worker (also true and misleading) who lived on the Rue de Romainville, which is geographically even further from the truth than the Rue Vavin.

It also seems clear that the distinction between the *collectionneur* of the Rue de Vaugirard and the *décorateur* of the Rue du Montparnasse was Atget's invention. (See note to pl. 88.)

Margaret Nesbit, in her very valuable introduction to the Musée Carnavalet's annotated catalog (1982) of that museum's own *Intérieurs* album, suggests that the work is a coded expression of Atget's political stance, and that it asks its viewers "to see style as a function of class." It seems likely that Atget's audience, rightly or wrongly, had never thought otherwise. If Atget, a man described by his friends as abrupt, outspoken to a fault, had intended this series to be an expression of his political beliefs, it is remarkable that he was so subtle about it. It seems to this viewer more likely that Atget did the series because he found the first such pictures that he made—those of his own apartment—fascinating and revealing, and that he wished to

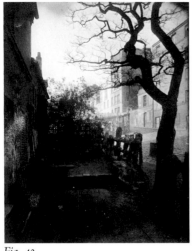 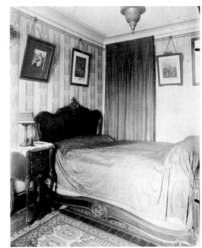

Fig. 49 Fig. 50 Fig. 51

further explore this line, and simultaneously produce an album that he could sell, especially if he stretched a little the social and occupational profile of his random sample. In fact, there was probably nothing random about Atget's sample. Since he had no official status that would facilitate his invasion of the bedrooms and kitchens of strangers, it seems likely that the residents of these rooms were his friends.

Pl. 81. *Intérieur de M^r C., décorateur, rue du Montparnasse.* (1910.) i:733. MoMA 1.69.3167

Pl. 82. *Intérieur ouvrier, rue de Romainville.* (1910.) i:741. MoMA 1.69.3177

The little print of the still life to the left of the mirror, perhaps a commercial giveaway expressing the best wishes of a tradesman, was probably produced in quantity, and it is not remarkable that it appears again in the series—in the room of the worker of the Rue de Belleville (Atget i:744).

Pl. 83. *Intérieur de M^r A., industriel, rue Lepic (Montmartre).* (1910.) i:770. MoMA Study Collection 84.61. Print by CAW, 1984

Pl. 84. *Intérieur de M^r C., décorateur appartements, rue du Montparnasse.* (1910.) i:731. MoMA Study Collection 84.62. Print by CAW, 1984

Pl. 85. *Intérieur de M^r C., décorateur appartements, rue du Montparnasse.* (1910.) i:730. MoMA Study Collection 84.63. Print by CAW, 1984

In his *Intérieurs* series Atget repeatedly moves the furniture, rearranges the table-top still lifes, and borrows objects from one room to complete his arrangement in another. The armchair beside the Empire couch in plate 85, its upholstery slightly frayed at the front of the seat, is the same as that next to the writing desk in plate 84.

Pl. 86. *Intérieur de M^me D., petite rentière, boulevard du Port Royal.* (1910.) i:728. MoMA Study Collection 84.64. Print by CAW, 1984. (In some copies of Vol. IV this plate is incorrectly dated on p. 122.)

Fig. 50. *Intérieur de M^me D., petite rentière, boulevard du Port Royal.* (1910.) i:707. MoMA 1.69.3175

Plate 86 was made sometime after figure 50; the lamp on the bedside table has been changed, but the shade has been preserved. It will be noted that Atget moved the prints visible above the bed in figure 50 to the left, so that they would appear in the picture reproduced here as plate 86. Atget made at least two other pictures in this room, one of which (Atget i:709) shows, in the mirror across the room, that there were indeed two beds.

Pl. 87. *Intérieur de M^me D., petite rentière, boulevard du Port Royal.* (1910.) i:726. MoMA Study Collection 84.65. Print by CAW, 1984. (In some copies of Vol. IV this plate is incorrectly dated on p. 123.)

Pl. 88. *Intérieur de M^r C., décorateur appartements, rue du Montparnasse.* (1910.) i:729. MoMA Study Collection 84.66. Print by CAW, 1984

Fig. 51. *Untitled.* (1912.) i:395. MoMA 1.69.3172

Fig. 52. *Intérieur de M^r B., collectionneur, rue de Vaugirard.* (1910.) i:760. MoMA Study Collection print, 1978

Fig. 53. *Untitled.* (1912.) i:394. MoMA Study Collection print, 1978

Two years after making the pictures for his *Intérieurs* albums Atget returned to one of the rooms photographed earlier and made three additional negatives. Figure 51 describes approximately the same corner of the studio of M^r C., décorateur, as that shown in plate 88. The glass-fronted cabinet, however, holds several objects (the statuette of the wrestlers, the dripglazed vase on the upper shelf, the vase on the top of the cabinet) that were shown in the albums as part of the holdings of M^r B., collectionneur (fig. 52). Figure 53 shows, in the lower left, the same occasional table and vase that appear in figure 52, but the ceramic masks above the soffit are those seen above the piano in plate 88. Plate 88 and figure 53 seem to show opposite ends of the same room. The stairway to the balcony was rebuilt sometime between 1910 and 1912 (the end of the old banister is

Fig. 52 Fig. 53 Fig. 54

visible in figure 52), and the remodeling was perhaps the occasion for Atget's return to the flat of his friend M^r B/C, collectionneur/décorateur.

Pl. 89. *Intérieur de M^r F., négociant, rue Montaigne.* (1910.) i:765. MoMA 479.80. Print by CAW, 1978

According to Atget's albums, M^me F., wife of M^r F., agent de change, or more frequently in Atget's captions négociant, was an amateur sculptor; it is perhaps her work that sits on the night table beside the magical bed.

Pl. 90. *Naturaliste, rue de l'Ecole de Médecine.* (1926–27.) PP:150. MoMA Study Collection 84.67. Print by CAW, 1984

The deer in the picture, just above the crane or egret, is at first almost invisible; once seen, the animal's presence is inescapable, but its position in space remains ambiguous. Is the creature inside the shop, or outside, and reflected in the window?

Pl. 91. *Le salon de M^me C., modiste, place Saint-André-des-Arts.* (1910.) i:738. MoMA Study Collection 84.68. Print by CAW, 1984

In the *Intérieurs Parisiens* albums that Atget sold to the Musée Carnavalet and the Bibliothèque Nationale, plate 91 and its pendant, another view of the same room, were included. They were the only pictures in the albums that represented public, commercial rooms. Their inclusion might be explained by the fact that the salon of Madam C. was (if Atget is in this case to be believed) at the same address as her living quarters. Even if true, the fact is not an especially persuasive reason for violating the coherence of the class of private rooms, and it is perhaps more likely that Atget included them because they were too good to leave out. Plate 91 especially presages Atget's best work of fifteen years later: the picture is not composed, not constructed by the placement of individual visual facts in an agreeable pattern on a neutral ground, but perceived: defined not as an equable construction but as a clear sensation.

Pl. 92. *Boulevard de Strasbourg, corsets.* (1912.) PP:379. MoMA Study Collection 84.69. Print by CAW, 1984

Fernand Léger reported in *The Machine Aesthetic* that he and a friend had watched a haberdasher work toward the perfect solution for the arrangement of seventeen vests, along with their attendant cuffs, ties, etc. "We were tired and left after the sixth, having been there for one hour watching this man, who, after adjusting his articles by a single millimeter, would go outside to have a look. Each time he went out, he was so absorbed that he didn't see us. Skillfully setting things just right, he arranged the spectacle, as if his whole future depended on it, his forehead tense and his eyes strained. . . . and his [work] was going to disappear and he would have to redo it in a few days with the same keen care." Léger would surely have admired the work of the person who did the window of corsets, and appreciated the spacing of the mannequins that makes the voids between them as lively and voluptuous as the dummies themselves.

Pl. 93. *Coiffeur, boulevard de Strasbourg.* (1912.) PP:378. MoMA 1.69.2320
Pl. 94. *Magasins du Bon Marché.* (1926–27.) PP:125. MoMA Study Collection 84.70. Print by CAW, 1978

By calendar measurement, the pictures reproduced as plates 92 and 93 are separated by thirteen years from the superb late shop-windows that begin in 1925 with *Magasin, avenue des Gobelins* (see pls. 97, 100, 101, 102) and that include the late windows of the *Magasins de Bon Marché* (pls. 94 and 98). The years between, however, had been largely filled with other photographic concerns, and by a half-dozen years of activity so drastically reduced that the period was virtually a temporary retirement. The subject matter of plate 93 was in effect put aside in 1912, and not seriously reconsidered until 1925, when Atget's vision, by some unknown alchemy, had become enormously richer and more adventurous. The earlier windows give us a poetry of unmodulated, surreal fact; the latter ones clarify—triumph over —a raw content of hallucinatory complexity.

The change in the mannequins themselves is also interesting; the dummy of the postwar years has squarer shoulders and a less attenuated neck, and has almost lost the little circles of shadow at the corners of the half-smiling mouth, recalling the mouth of

Fig. 55

Fig. 56

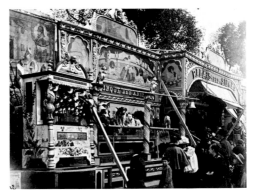

Fig. 57

a child that has been eating chocolate in secret. In the thirties the mouth corners would become as sharply pointed as daggers.

Pl. 95. *Coiffeur, Palais Royal.* (1926–27.) EP:152. MoMA 482.80. Print by CAW, 1978

The visual activity and the richness of information at the edges of Atget's late pictures are consistently so dense that one is inclined to believe that they were studied with the most punctilious attention. It should also be admitted that Atget was not consistently careful about the trimming of the black borders of his prints, which he apparently did with scissors. (Joel Snyder has suggested that he did this before treating his prints in the gold toner solution, since the jet-black borders would absorb most of the precious gold.) Because of Atget's imprecision in trimming, two of his prints from the same negative sometimes vary in their dimensions by a quarter-inch or even more, but the edges in each case seem visually active and rich in information. It was perhaps not so much edges that he worried about as the whole visual field; as in a fine masonry wall, even a random detail should be beautiful. Or, one might say that Atget's framing, his decision about what the picture includes, is so confident in broad concept that picky decisions about sixteenths of inches at the border are unimportant.

Nevertheless, in the best of late Atget we would not wish to sacrifice a sliver. In plate 95, the left edge seems to show us the minimum that we need for a sense of the age and character of the building; the top edge identifies the coiffeur's specialty, and teaches us how to say permanent wave in French; the lower right corner tells us something interesting about his clientele; and the right edge does two things: the column of light establishes, with the white post on the left, a frame for the marvelous creatures in the window, and it provides a background for the single spike of the iron fence, which explains nothing but suggests much, including privilege, and safety from the vulgar affairs of the street.

Pl. 96. *Coiffeur, avenue de l'Observatoire.* (1926.) PP:119. MoMA 1.69.1546

Fig. 54. *Coiffeur, avenue de l'Observatoire.* (1926.) PP:118. MoMA 1.69.2671

Figure 54 is a superb picture, worthy of Atget at the height of his powers; every square inch of the sheet works efficiently, and rewards attention. Plate 96, Atget's next exposure, demonstrates Atget's ability near the end of his life to condense and intensify what was already simple and strong. The mannequin in the middle is a newer model than those that flank her; she is cooler and more independent, and less obviously eager to please.

Pl. 97. *Magasin, avenue des Gobelins.* (1925.) PP:84. MoMA 1.69.1379

From a documentary point of view, plate 97 is interesting as evidence that an ideal of childhood as smarmy, toadyish, and adult-oriented as the one illustrated here already existed sixty years ago.

Pl. 98. *Magasins du Bon Marché.* (1926–27.) PP:127. MoMA 127.50

Fig. 55. *Magasins du Bon Marché.* (1926–27.) PP:126. MoMA 1.69.2130

The 1904 Baedeker for Paris says that the department stores, the *grands magasins de nouveautés*, were gradually superseding the smaller shops because of their abundant choice of goods, and that the most important of these establishments was perhaps the Bon Marché, although it was "rather distant from the center of the town." It is at the intersection of the Rue du Bac and the Rue de Sèvres, an easy walk south from the Pont Royal. Plate 98 and figure 55 show two of three pictures that Atget made of the windows apparently on the same day, probably in June of 1926.

Pl. 99. *Untitled [toupee shop, Palais Royal].* (1926–27.) PP:153. MoMA 211.81. Print by Berenice Abbott, n.d.

Plate 99 is reproduced from an early print by Berenice Abbott. The negative is presumed lost or broken, and the authors know of no existing print from Atget's hand. The establishment shown

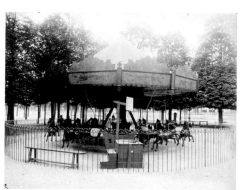

Fig. 58

Fig. 59

Fig. 60

here is the same as that in plate 95; toupees were not its only specialty.

Pl. 100. *Magasin, avenue des Gobelins.* (1925.) PP:85. MoMA 357.61. Same as MoMA 1.69.2457

Pl. 101. *Magasin, avenue des Gobelins.* (1925.) PP:83. MoMA 1.69.1544

Pl. 102. *Avenue des Gobelins.* (1925.) PP:82. MoMA Study Collection 84.71. Print by CAW, 1984. Same as MoMA 1.69.2441

It appears that Atget made four negatives of the windows of this store on a single day in the spring of 1925. (The identity of negative PP:81 has not been established; it could have been the first in a sequence of five of this subject.) The fluency and certainty of Atget's late vision is demonstrated repeatedly by such sequences, in which there are no weak or uninteresting pictures. The four known pictures are reproduced in this volume as plates 97, 100, 101, and 102.

Man Ray thought (*Image*, Apr. 4, 1956) that the reflections in Atget's pictures were unintentional, that they "just came out that way." If he meant that the mature Atget did not see and consider that part of his images formed by reflections, the opin-

ion is not credible. It is only in Atget's late work that reflections assume the visual importance and the formative power exhibited in the pictures on the Avenue des Gobelins. As in his work at Saint-Cloud and Sceaux, the reflection is no less a part of his subject matter than the corporeal object reflected. By the twenties Atget understood that all of the picture, from corner to corner, was a reflection.

James Borcoman has pointed out that the domed building reflected in the window is part of the Gobelins factories. Tapestries had been made in the factories for almost three centuries; in 1662 Louis XIV (at the instigation of Colbert) bought the establishment for the state and placed it under the direction of his chief painter, Charles Le Brun. The building visible in the window appears to be the Gobelins museum, built in 1914.

Pl. 103. *Naturaliste, rue de l'Ecole de Médecine.* (1926–27.) PP:151. MoMA Study Collection 84.72. Print by CAW, 1984

In thirty years Atget made some nine hundred negatives for the three parts of his Picturesque Paris series. After plate 103, Atget made eight more exposures in the series, including the pictures reproduced here as plates 40, 41, 95, and 99, and as figures 22 and 13—Atget's last attempt at the Place Saint-Médard. The

Fig. 61

Fig. 62

Fig. 63

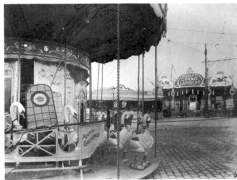

Fig. 64

Fig. 65

Fig. 66

shop shown here is the same as that in plate 90, the preceding exposure in the series.

Pl. 104. *Fête des Invalides.* (1926.) PP:113. MoMA 1.69.1496

Fig. 56. *Fête des Invalides.* (1898.) PP:3097. MoMA 1.69.474

Fig. 57. *Fête des Invalides.* (1898.) PP:3101. MoMA 1.69.444

Fig. 58. *Guignol, jardin Luxembourg.* (1898.) PP:356, formerly
PP:2997. MoMA 1.69.4176

Fig. 59. Eugène Guérard. *Théâtre de Guignol, Champs-Elysées.*
1856. Lithograph. Alan Cook, Los Angeles

From the beginning of his career Atget paid close attention to the street fairs and the *théâtres de Guignol* (Punch and Judy shows) of the parks. The development of his style with this subject echoes that which is visible across the entire range of his work. The early pictures are crowded with interesting facts, fitted into the frame in any space available, and illuminated by a light of disinterested objectivity. Figures 56, 57, and 58 are typical. These pictures apparently had a considerable range of commercial potential; figure 56 was acquired by the Bibliothèque Historique de la Ville de Paris in 1900, and figure 57 was reproduced in 1903 in F. Berkeley Smith's book *How Paris Amuses Itself*, published in New York and London.

Pl. 105. *Fête du Trône.* (1925.) PP:69. MoMA 1.69.442

Fig. 60. *Tuileries, chevaux pour les enfants.* (1911–12.) t:284.
MoMA 1.69.2523

Both the graphic clarity and the dramatic intensity of the nominally simple photograph reproduced in plate 105 are the result of Atget's very low vantage point, which creates the shape of the hovering black ellipse against the glowing white sky.

Pl. 106. *Fête de Vaugirard.* (1925.) PP:59. MoMA Study
Collection 84.73. Print by CAW, 1984. Same as
MoMA 1:69.432

Fig. 61. *Fête de Vaugirard.* (1922.) AP:6315. MoMA 1.69.470

Fig. 62. *Fête de Vaugirard.* (1926.) PP:99. MoMA 1.69.463

Fig. 63. *Fête de Vaugirard.* (1927.) PP:142. Print by CAW,
1984. Same as MoMA 1.69.2937

The *fêtes foraines* appeared in their respective quarters of Paris at their appointed seasons. Over the years Atget photographed those of the Invalides, Gobelins, Vaugirard, Trône, Villette, and perhaps others. With the possible exception of the Fête du Trône, that of Vaugirard was apparently Atget's favorite; he photographed it in 1922, and again in each of the last four years

of his life, from 1924 through 1927, exposing a total of at least eighteen plates there, including seven in 1927. Almost all of these show a single exhibit, the Cirque Fanni. The complete range of these pictures shows that the enterprise underwent a radical architectural change between 1922 and 1924, although the old ticket booth has been preserved. Figure 62, although not one of Atget's more successful pictures, exhibits the intelligent curiosity that identifies his work as a whole. As an old theater man he was interested in the difference between what one saw from the front and the back of the proscenium.

Pl. 107. *Foire.* (1923.) PP:29. MoMA Study Collection 84.74. Print by CAW, 1984. Same as MoMA 1.69.2931

Pl. 108. *Fête de la Villette.* (1925.) PP:56. MoMA 1.69.435
Pl. 109. *Fête de la Villette.* (1926.) PP:96. MoMA 1.69.430
Fig. 64. *Fête de la Villette.* (1926.) PP:94. MoMA 1.69.3009

Atget's early carousels are addressed on axis, and the entire machine is included. By 1925 he regards the thing not as an object but a subject, to be approached with the same freedom as a fragment of landscape. In plates 108 and 109 both the subject matter and the formal scheme are similar enough to have made this writer remember the pictures (before seeing them side by side) as showing the same merry-go-round. Close inspection shows that the rabbits in plate 109 are not wearing bow ties. (The upper-left corner of plate 108 shows a displacement of the image that is difficult to understand. Presumably Atget, or a passing urchin, kicked the tripod during an extended exposure, but the record of the double image is remarkably inconsistent.)

Pl. 110. *Fête de Vaugirard.* (1926.) PP:97. MoMA 1.69.2932
Pl. 111. *Fête de Vaugirard.* (1926.) PP:98. MoMA 1.69.427

The merry-go-round shown in plates 110 and 111 was designed for the 1925 Exposition Internationale des Arts Décoratifs by the distinguished fashion designer Paul Poiret, and executed by the sculptor Pierre Vigoureux. The piece was called Manège [merry-go-round] de la Vie Parisienne, and it was in effect one more, perhaps the last, reprise of the old catalog of Paris street types, a last distorted echo of the *cris de Paris*. If Atget's caption is correct, Poiret's carousel was by the next year adopted, or adapted, by the Fête de Vaugirard, and became part of an ordinary street fair.

Pl. 112 *Fête du Trône.* (1926.) PP:102. MoMA Study Collection 84.75. Print by CAW, 1984
Fig. 65. *Fête du Trône.* (1926.) PP:103. MoMA Study Collection 84.77

There is in Atget's last work, in spite of its poise and perfect stillness, a hint of the apocalyptic: the broken classical gods in their decaying gardens, the skeletons and stuffed animals, the deranged, transparent mannequins, the creatures of the carousels, escaped from medieval fairy tales, suggest a vision of a world almost unhinged. In figure 65, the legend on the painted carnival flat says there is a fire in the jungle.

Pl. 113. *Fête, avenue de Breteuil.* (1913.) PP:410. MoMA 1.69.456
Fig. 66. Séeberger Frères. *Parade de foire.* (1905–10.) Caisse Nationale des Monuments Historiques

Most of the varieties of subject matter that Atget attempted— art and architecture, landscape, commerce, street life, amusements—were explored also by other photographers of his time, and were in broad principle familiar to artists long before the invention of photography. It took Atget several years to find and to trust the special sensibility and method that make his work unique, and that required the abandonment of other potentially equal possibilities. The best work of the Séeberger Brothers, for example (see fig. 66), suggests one of the areas of investigation that were incompatible with Atget's own austere intuition.

Pl. 114. *Fête du Trône.* (1924.) PP:43. MoMA 1.69.437

Pl. 115. *Fête du Trône.* (1925.) PP:67. MoMA 1.69.441

Pl. 116. *Fête du Trône.* (1925.) PP:68. MoMA 1.69.1641

If Atget had died at sixty he would be remembered as a photographer of exceptional interest, but he would not have done the work for which photographers revere him most deeply. It is Atget's work of the twenties that is most extraordinary, and most difficult to analyze. We might say that Atget in his last years discovered a new stratum of facts, and that the description of these new facts produced pictures that are in their sense and their structure different from any photographs before them.

Plate 116 shows the chair and a shoe of Armand the Giant, and the chair and a shoe of the smallest man in the world, and two photographs, and a light bulb that reminds us of the light bulbs that in comic strips symbolize sudden enlightenment, all patterned against the dark interior like bits of memorabilia in a collage. The meaning of the picture is in its facts, and in the pattern of the facts, and in the questions it proposes concerning facts not included here. Atget's contemporary Raymond Poincaré said, "If our means of investigation should become more and more penetrating we should discover the simple under the complex; then the complex under the simple; then anew the simple under the complex; and so on without ever being able to forsee the last term."

A Note on Atget's Prints

Atget printed his 18 x 24 cm glass negatives exclusively on printing-out paper, the ordinary medium for photographic documents in the last decades of the nineteenth century. This sort of paper is easy to use: the image gradually appears when the paper, placed beneath a negative, is exposed to daylight until the desired tonality is achieved, after which the print is fixed and washed. Unlike most photographic papers, it does not require a developing bath to bring out the latent image after exposure in a darkroom, and it is not compatible with the use of enlargers.

Atget remained faithful to his chosen technique throughout his long career, but in its course the papers he used changed. From the outset (c. 1890) until 1914 he printed only on albumen paper. Thin, shiny, with a tendency to curl, this paper reveals, on close inspection, a faintly pebbled surface with some reticulation or crackling of the dried egg-white emulsion. Sometimes a watermark, "B.F.K. Rives No 74," is visible in the paper. The color of these albumen prints, achieved through gold toning, ranges from chamois (in prints of poor conservation) to deep sepia.

At the time of World War I, gelatin replaced albumen as the common support for the silver emulsions of photographic papers. It is not clear whether Atget adopted a new "gelatin-albumen" paper or managed to find a supplier of the reliable old standard, but he did continue with albumen or albumen-like papers in his normal practice in the 1920s. The postwar albumen paper Atget used is similar to its predecessor except that it shows no surface craquelure and no watermark, and has whiter whites and a purplish cast in the deeper tones.

After the war Atget also employed, upon occasion, three other papers, all on somewhat heavier stock. One of them, mat albumen or arrowroot paper, has a soft, velvety texture and a cool, gray-to-violet range of color. It has been mistaken for platinum paper because of its similar tonality and elegance. The other two papers, of rolled stock with a "baryta" clay coating, have a distinctive machine-made smoothness and rigidity. One of these papers, which Atget favored at the end of his life, has a glossy polish and dark russet and chocolate tones. The other, which he used but rarely, has a mat surface without the characteristic sueded nap of the arrowroot paper.

In the half-century since Atget's death others have printed his negatives. From about 1930 through the late '60s, Berenice Abbott made black-and-white developing-out prints from negatives in the Abbott-Levy Collection. These were sold (as were some of Atget's original prints) through Julien Levy's gallery in New York. In 1956, Miss Abbott produced a portfolio of twenty such prints in an edition of one hundred. More recently, Pierre Gassmann made prints from several dozen of Atget's negatives at the archives of Les Monuments Historiques, in Paris, for a traveling exhibition organized by that institution in 1977.

During the same period, Joel Snyder and the Chicago Albumen Works were commissioned by The Museum of Modern Art to print twelve negatives from the Abbott-Levy Collection, in an edition of one hundred, for sale to the Museum's members. Printed on the historically appropriate albumen printing-out paper, these "restrikes" closely resemble Atget's original prints. They are embossed in the lower right corner with the stamp CAW-MoMA, plus the date. The Chicago Albumen Works and Richard Benson also produced prints for the Museum's collection and archives and for the exhibition program that accompanies the present volumes.

Bibliography

The following list of books and articles is selective; it includes only references that provided either new information about Atget and his work or historically noteworthy opinions of his art. Reproductions of Atget's photographs are not noted here, nor, for the most part, are the numerous reviews of books and exhibitions. Those seeking access to the full literature may turn to William Johnson's "Eugène Atget: A Chronological Bibliography," *Exposure*, 15, no. 2 (May 1977), pp. 13–15, and to the bibliographies in Maria Morris Hambourg's dissertation, "Eugène Atget, 1857–1927: The Structure of the Work" (Columbia University, 1980) and in Margaret S. Nesbit's dissertation, "Atget's Seven Albums, in Practice" (Yale University, 1983).

A collection of early articles concerning Atget also exists in the form of a scrapbook compiled by Berenice Abbott in the late 1920s. It contains, among other things, articles by Robert Desnos, Florent Fels, and Pierre Mac Orlan, and the catalog of the Premier Salon Indépendant de la Photographie. There is a copy of the scrapbook in the Atget Archives, MoMA.

I. Books and Catalogs

1. Abbott, Berenice. *The World of Atget*. New York: Horizon Press, 1964.

2. Adams, William Howard. *Atget's Gardens*. London: Gordon Fraser, 1979.

3. *Atget, Géniaux, Vert: Petits Métiers et types parisiens vers 1900*. Introd. by Bernard de Montgolfier. Paris: Musée Carnavalet, 1984.

4. *Atget: Photographe de Paris*. Introd. by Pierre Mac Orlan. Paris: Henri Jonquières, 1930; New York: E. Weyhe, 1930. Also published as *Eugène Atget: Lichtbilder*. Introd. by Camille Recht. Leipzig: Henri Jonquières, 1930.

5. Borcoman, James. *Eugène Atget, 1857–1927*. Ottawa: National Gallery of Canada, 1984.

6. Christ, Yvan. *Saint-Germain-des-Prés 1900, vu par Atget*. Paris: Le Comité de la Quinzaine, 1951.

7. ———. *Le Paris d'Atget*. Paris: Balland, 1971.

8. Forberg, Gabrielle, and Leube, Dietrich, eds. *Eugène Atget: Lichtbilder*. Munich: Rogner and Bernhard, 1975. (A substantially altered reedition of the 1930 monograph of the same name; see entry 4 above.)

9. Honnef, Klaus, ed. *Eugène Atget (1857–1927): Das Alte Paris*. Cologne: Rheinland-Verlag, 1978.

10. Leroy, Jean. *Atget, magicien du Vieux Paris*. Paris: Pierre-Jean Balbo, 1975.

11. Lifson, Ben. *Eugène Atget*. The History of Photography Series, vol. 14. Millerton, N.Y.: Aperture, 1980.

12. Martinez, Romeo. *Eugène Atget*. Milan: Electa Editrice, 1979.

13. Nesbit, Margaret, and Reynaud, Françoise. *Eugène Atget, 1857–1927: Intérieurs parisiens*. Paris: Musée Carnavalet, 1982.

14. Pougetoux, Alain, and Martinez, Romeo. *Eugène Atget, photographe, 1857–1927*. Paris: [Musées de France], 1978. Reprinted as *Atget: Voyages en ville*. Paris: Chêne / Hachette, 1979.

15. Puttnies, Hans Georg. *Atget*. Cologne: Galerie Rudolf Kicken, 1980.

16. Trottenberg, Arthur, ed. *A Vision of Paris: The Photographs of Eugène Atget, the Words of Marcel Proust*. New York: Macmillan, 1963.

II. Articles

17. Abbott, Berenice. "Eugène Atget." *Creative Art*, 5, no. 3 (Sept. 1929), pp. 651–56.

18. ———. "Photographer as Artist." *Art Front*, 16 (Sept.–Oct. 1936), pp. 4–7.

19. ———. "Eugène Atget, Forerunner of Modern Photography." *U.S. Camera*, 1, no. 12 (Autumn 1940), pp. 20–23, 48–49, 76; and 1, no. 13 (Winter 1940), pp. 68–71.

20. ———. "Paris in the Early 1900's." *Harper's Bazaar*, 74, no. 2750 (Apr. 1941), pp. 46, 74–75.

21. ———. "Eugène Atget." *Complete Photographer*, no. 6 (1941), pp. 335–39.

22. ———. "Atget, Photographer of Paris." *Minicam Photography*, 8, no. 7 (Apr. 1945), pp. 36–41, 95.

23. ———. "Eugène Atget: The Peopled Streets." *Creative Camera*, no. 73 (July 1970), pp. 202–03.

24. Adams, Ansel. "Photography." *Fortnightly*, 1, no. 5 (Nov. 6, 1931), p. 25.

25. Alvarez-Bravo, Manuel. "Adget [sic]: Documentos para artistas." *Artes plasticas*, no. 3 (Autumn 1939), pp. 68–76, 78.

26. Badger, Gerry. "Eugène Atget: A Vision of Paris." *British Journal of Photography*, 123, no. 6039 (Apr. 23, 1976), pp. 344–47.

27. Bost, Pierre. [Premier Salon Indépendant de la Photographie]. *La Revue hebdomadaire*, no. 24 (June 14, 1928), pp. 356–59.

28. Brassaï [Gyula Halász]. "My Memories of E. Atget, P. H. Emerson, and Alfred Stieglitz." *Camera*, 48, no. 1 (Jan. 1969), pp. 4–13, 21, 27, 37.

29. Desnos, Robert. "Emile Adget [*sic*]." *Merle*, new series, no. 3 (May 3, 1929). Reprinted in *Nouvelles-Hébrides et autres textes, 1922–1930* (Paris: Gallimard, 1978).

30. Ellis, Ainslee. "The True Value of Atget." *British Journal of Photography*, 119, no. 8 (Feb. 25, 1972), pp. 158–63.

31. Evans, Walker. "The Reappearance of Photography." *Hound and Horn*, 5, no. 1 (Oct.–Dec. 1931), pp. 125–28.

32. Fels, Florent. "Adjet [*sic*]." *L'Art vivant*, 7 (Feb. 1931), p. 28.

33. ———. "Le Premier Salon Indépendant de la Photographie." *L'Art vivant*, 4 (June 1, 1928), p. 445.

34. Flanner, Janet. "Eugène Atget (1856–1927)." *The New Yorker*, May 4, 1929, p. 79. Reprinted in *Paris Was Yesterday (1925–39)*. New York: Popular Library, 1972.

35. Fraser, John. "Atget and the City." *Cambridge Quarterly*, 3 (Summer 1968), pp. 199–233. Reprinted in *Studio International* (Dec. 1971), pp. 182–83.

36. Fuller, John. "Atget and Man Ray in the Context of Surrealism." *Art Journal*, 36, no. 2 (Winter 1976–77), pp. 130–38.

37. Gallotti, Jean. "Atget." *L'Art vivant*, 5 (Jan. 1, 1929), pp. 20–21, 24.

38. George, Waldemar. "Adget [*sic*], photographe de Paris." *La Photographie*, special number of *Arts et métiers graphiques*, no. 16 (Mar. 15, 1930), pp. 134, 136, 138.

39. Greenberg, Clement. "Four Photographers." *New York Review of Books*, 1, no. 11 (Jan. 23, 1964), pp. 8–9.

40. Hambourg, Maria Morris. "Atget, Precursor of Modern Documentary Photography." *Observations, Essays on Documentary Photography: Untitled*, no. 35, Carmel, Cal.: The Friends of Photography, 1984, pp. 24–41.

41. Hill, Paul, and Cooper, Tom. "Interview: Man Ray." *Camera*, 54, no. 2 (Feb. 1975), pp. 37–40.

42. Katz, Leslie. "The Art of Eugène Atget." *Arts Magazine*, 36, nos. 8–9 (May–June 1962), pp. 32–36.

43. Kirstein, Lincoln. [Review of Abbott, *The World of Atget*.] *The Nation*, 199 (Dec. 14, 1964), p. 472.

44. Kospoth, B. J. "Eugène Atget." *Transition*, no. 15 (Feb. 1929), pp. 122–24.

45. Leroy, Jean. "Who Was Eugène Atget?" *Camera*, 41, no. 12 (Dec. 1962), pp. 6–40. Reprinted in *Camera*, 57, no. 3 (Mar. 1978), pp. 40–42.

46. ———. "Atget et son temps, 1857–1927." *Terre des images*, 5–6, no. 3 (1964), pp. 357–72.

47. ———. "Photojournal: Précisions sur Atget." *Photo*, special no., 122 (Nov. 1977), p. 15.

48. Levy, Julien. "Atget." In *Memoir of an Art Gallery*, pp. 90–95. New York: G. P. Putnam's Sons, 1977.

49. Mac Orlan, Pierre. "La Photographie et le fantastique social." *Les Annales*, no. 2321 (Nov. 1, 1928), pp. 413–14.

50. ———. "Atget." *L'Art vivant*, no. 230 (Mar. 1939), p. 48.

51. Martinez, Romeo. "Eugène Atget in Our Time." *Camera*, 45, no. 12 (Dec. 1966), pp. 56, 65–66.

52. Mayor, A. Hyatt. "The World of Atget." *Metropolitan Museum of Art Bulletin*, NS 10 (Feb. 1952), pp. 169–71.

53. ———. "On Eugène Atget." *Metropolitan Museum of Art Bulletin*, 27, no. 7 (Mar. 1969), p. 348.

54. Michaels, Barbara. "Dating Atget: An Introduction." *Exposure*, 15, no. 2 (May 1977), p. 12.

55. ———. "An Introduction to the Dating and Organization of Eugène Atget's Photographs." *Art Bulletin*, 61, no. 3 (Sept. 1979), pp. 460–68.

56. Pougetoux, Alain, and Martinez, Romeo. "Eugène Atget." *Camera*, 57, no. 3 (Mar. 1978), pp. 21–39.

57. Reyher, Ferdinand. "Atget." *Photo Notes* (Fall 1948), pp. 16–21.

58. Rosenfeld, Paul. "Paris, the Artist." *The New Republic*, 65, no. 843 (Jan. 28, 1931), pp. 299–300.

59. Szarkowski, John. "Atget." *Album*, no. 3 (Apr. 1970), pp. 4–12.

60. ———. "Atget's Trees." In *One Hundred Years of Photographic History: Essays in Honor of Beaumont Newhall*, ed. Van Deren Coke, pp. 162–68. Albuquerque: University of New Mexico Press, 1975.

61. Valentin, Albert. "Eugène Atget." *Variétés*, 8 (Dec. 15, 1928), pp. 403–07.

62. White, Minor. "Eugène Atget, 1856–1927." *Image*, 5, no. 4 (Apr. 1956), pp. 76–83.

The text for
THE WORK OF ATGET: MODERN TIMES
is set in Bembo monotype.
Type composition by The Stinehour Press
Halftone negatives by Richard Benson
Printing by The Meriden Gravure Company
Binding by Sendor Bindery, Inc.